Gift of a Letter

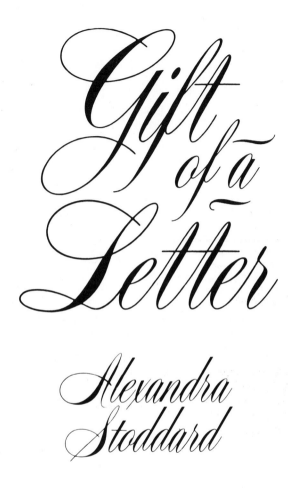

Gift of a Letter

Alexandra Stoddard

Illustrations by John Burgoyne

AVON BOOKS ◆ NEW YORK

AVON BOOKS
A division of
The Hearst Corporation
1350 Avenue of the Americas
New York, New York 10019

The Doubleday edition contains the following Library of Congress Cataloging in Publication Data:

Stoddard, Alexandra.
 Gift of a letter / Alexandra Stoddard.—1st ed.
 p cm.
 1. Letter-writing. I. Title.
 BJ2101.S74 1990 89-23759
 395'.4—dc20 CIP

First Avon Books Trade Printing: November 1991

AVON TRADEMARK REG. U.S. PAT. OFF. AND IN OTHER COUNTRIES, MARCA REGISTRADA, HECHO EN U.S.A.

Printed in the U.S.A.

QPM 10 9 8

Dearest Alexandra and Brooke,
I dedicate *Gift of a Letter*
to each of you.

STONINGTON, CONNECTICUT

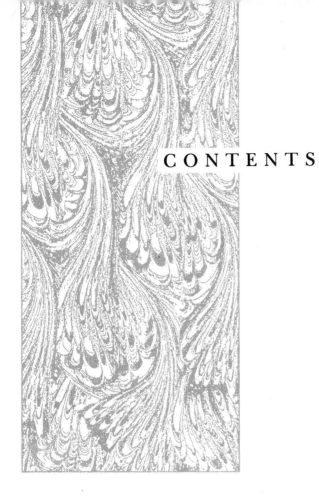

C O N T E N T S

"This is my letter to the world"

—EMILY DICKINSON

INTRODUCTION

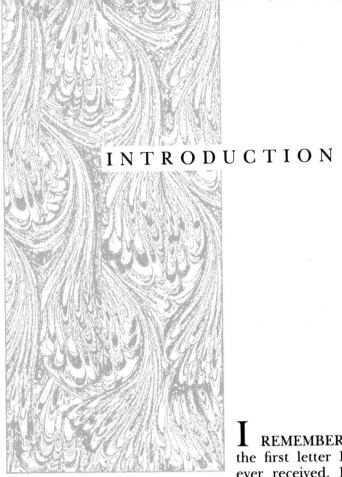

I REMEMBER the first letter I ever received. I was five years old, and my godmother sent a note to me in Connecticut inviting me to her farm in Framingham, Massachusetts, for the weekend. What I remember so vividly is that my full name was spelled out on the envelope: ALEXANDRA GREEN JOHNS. The letter was signed by an adult I held in great admiration: "Love, Mitzi." To my godmother, I was a real-live person, not just my parents' little girl.

Ever since then, I've been passionate about letter writing and receiving. Some women buy a new shade of lipstick when they need their spirits lifted; I write a letter. For me, once in the mood, it is never a question of finding time—there is always time to write, just as there is time to enjoy life. I wonder, how can we *not* find time to sweeten our lives? I know that my own life would become impoverished if I were somehow forced to cease my letter writing.

An inspired letter can be as riveting as a stare. It can move us to tears, spur us to action, provoke us, uplift us, touch us. Transform us. When written from the heart, letters are dreams on paper, wishes fulfilled, desires satisfied. Letters can be powerful.

One of the most famous letters in the history of the English language is one we can all relate to, written in 1755 by Samuel Johnson, who turned down an insincere offer of help from someone of power. His letter is a serious one about struggle and triumph, a great example of the power of the pen. In 1747 Johnson planned to write an authoritative English dictionary and, looking for a patron, he sent a prospectus to the pompous Earl of Chesterfield, who was then Secretary of State in England. The Earl pretended he was not at home when Johnson came calling, yet despite the put-down, Johnson continued to slave on the dictionary for seven years. When the dictionary was completed, Chesterfield heard it was brilliant and wanted to merit the dedication so he wrote two essays recommending it, which didn't help at that late date. Thomas Carlyle referred to Johnson's reply as "that far-famed Blast of

Doom proclaiming that patronage should be no more."

<div align="right">February 7, 1755</div>

My Lord,

I have been lately informed, by the proprietor of the *World,* that two papers, in which my Dictionary is recommended to the public, were written by your Lordship. To be so distinguished, is an honour, which, being very little accustomed to favours from the great, I know not well how to receive, or in what terms to acknowledge.

When, upon some slight encouragement, I first visited your Lordship, I was overpowered, like the rest of

mankind, by the enchantment of your address; and could not forbear to wish that I might boast myself *Le vainqueur du vainqueur de la terre;*—that I might obtain that regard for which I saw the world contending; but I found my attendance so little encouraged, that neither pride nor modesty would suffer me to continue it. When I had once addressed your Lordship in publick, I had exhausted all the art of pleasing which a retired and uncourtly scholar can possess. I had done all that I could; and no man is well pleased to have his all neglected, be it ever so little.

Seven years, my Lord, have now past, since I waited in your outward rooms, or was repulsed from your door; during which time I have been pushing on my work through difficulties, of which it is useless to complain, and have brought it, at last, to the verge on publication, without one act of assistance, one word of encouragement, or one smile of favour. Such treatment I did not expect, for I never had a Patron before.

The shepherd Virgil grew at last acquainted with Love, and found him a native of the rocks.

Is not a Patron, my Lord, one who looks with unconcern on a man struggling for life in the water, and, when he has reached ground, encumbers him with help? The notice which you have been pleased to take of my labours, had it been early, had been kind; but it has been delayed till I am indifferent, and cannot enjoy it; till I am solitary, and cannot impart it; till I am known, and do not want it. I hope it is no very cynical asperity not to confess obligations where no benefit has been received, or to be unwilling that the Publick should consider me as owing that to a Patron, which

Providence has enabled me to do for myself.

Having carried on my work thus far with so little obligation to any favourer of learning, I shall not be disappointed though I should conclude it, if less be possible, with less; for I have been long wakened from that dream of hope, in which I once boasted myself with so much exultation.

> My Lord,
> Your Lordship's most humble,
> Most obedient servant,
> Sam. Johnson

The Dictionary was not dedicated to Lord Chesterfield and Samuel Johnson's famous stinging letter was never answered.

Long before I dreamed I'd write for publication, letters were my chief literary outlet for self-expression. Then when I was sixteen and traveling around the world, I also started a journal. I remember being torn between writing to myself in a book I knew no one would ever read, and sharing my experiences with a boyfriend or parent. Eventually I realized that both forms of writing are life-enhancers—they enrich in different ways. I keep a journal for myself—to chart my growth through day-to-day emotions and reactions to people and events. I write letters to share with others my intense passions for life—my loves, my losses, my fantasies, my dreams. Letters fuse my fierce independence with my need for others. Letters make me happy.

Letters are magical. I never throw out a good letter. They enable us to nurture, connect and communicate with a worldwide circle of friends—friends we otherwise might never have met. They open doors to innumerable emotions and experiences. Letters document the chapters in our lives—our discoveries, our passions, our sorrows and growth as well as all the ebb and flow inevitable in life. Letters allow us to be personal, natural and specific. More than any other medium, letters provide an uninhibited view of everyday life—the most accurate and natural form of autobiography. Like an intimate conversation between friends, they record immediate circumstances, events, news, gossip and feelings. They are detailed; they act as a zoom lens into specific moments, experiences and emotions. When I write a letter to a friend, I bring that person into my day, describing domestic events, my mood, my attitude, colors and pleasures. A cut finger, my cold, news of my children, the weather, music, smells from the kitchen, are all shared. If I write a letter late at night in the intimacy of one lamp I tend to describe my surroundings and the stillness. If I write a letter from a restaurant I might describe what looks good on the menu. Scenes are painted, stories told that linger as long as the letter, and beyond.

A letter can be written for any number of reasons—joy, pain, neglect, love, lust, desire, loneliness, flight of fancy, disgust, ecstasy—but always there is overwhelming need to share, to connect, to feel understood. That's why a letter is a blessing, a great and all-too-rare privilege. More personal than even a favorite book, more alive than a treasured possession, a

letter is written, addressed and mailed to one, and only one, person. Consequently, a letter holds enormous impact. Whenever one needs to feel close to a good friend, all one has to do is write a letter.

A world of difference separates a phone call from a letter. The phone is a utility—a convenience like a refrigerator or a washing machine. A letter is a gift. It can turn a private moment into an exalted experience. Unlike the phone, a letter is never an interruption. A letter doesn't require immediate attention; it can be saved for the appropriate time and place and savored. Whenever I answer the telephone, I am at the mercy of another person's schedule. A letter, on the other hand, is a treat with no strings attached. To Edith Wharton, who left behind over two thousand letters (many available at Yale's Beinecke Library and collected in *The Letters of Edith Wharton,* published in 1988 by Scribner), "incoming mail" was one of life's great treats.

The problem, obviously, is that many of us are afraid to write letters. If I initiate a letter to you, I'm reaching out in a personal and often vulnerable way. It's a risky activity. What if you don't write me back? Does that mean you don't care? What impression did my letter make? The irony is that most people *will* write back! Maybe not today or tomorrow, but someday. Why do we tend to wait for others to make the first move?

A good letter doesn't have to be long; it can be a few sentences, several words of thanks and expressions of affection. And as much as I adore all the paraphernalia of letter writing—a fountain pen, a bottle of ink, pretty

stationery, a writing table—these accoutrements aren't essential. You don't have to sit down at a neat little writing desk to scribble a letter. The fact that you write it at all is a compliment. One of the most marvelous things about letter writing is the fact that you can be anywhere in the world, at any time, and put pen to paper. Granted, in these days of cellular phones and high technology, writing may sound like a bit of a chore. But it doesn't have to be—it won't be, once you start. In fact, once you start you won't be able to stop. I know that even the thought that I might open my mailbox and uncover a personal letter is enough to brighten my day.

Most people who write letters derive enormous pleasure in doing so. One reason is that although letters come from a very personal need to share, they are

also, in a sense, a deliciously selfish act; they force the recipient to focus his attention on you—to think solely of you if only for the briefest of moments. Letters require less time than a visit; they are not as complicated and are remarkably satisfying when effervescent with enthusiasm. A letter allows you to keep a certain distance, which is understood: A warm and tender letter is often close enough and the recipient is free to read between the lines. I concede that a letter isn't a substitute for a visit, but it is an experience all its own and it fills one's imagination with possibilities.

Letters give life a rich dimension. They can be saved, savored, reread and treasured for hundreds of years.

Sitting at a dinner party recently, a judge I know told me he keeps a book of E. B. White's letters next to his bed and rereads several at a time before going to sleep. When I told him I do the same thing—the bookshelves closest to my bed are stocked full of collections of correspondence—he smiled and told me this story.

After his lawyer father died, the judge discovered bundles of correspondence while cleaning out his father's desk in his Boston law firm. There were letters from appreciative clients, letters the judge had sent his parents from overseas during World War II, love letters, sympathy letters, notes from friends and family. Although this wealth of information, intimacy and personal memorabilia may never be widely published, the family is gathering the letters together and arranging them chronologically into a family scrapbook. They are considering a small private printing so that future

generations can become acquainted with their ancestor through the epistles of love and life he left behind.

Most of the letters I write and receive are letters of appreciation and sharing. But as with everyone else, occasionally life's events require me to write serious, difficult letters. I've learned how to say "no" in a letter; I find the written word less ambiguous than a phone conversation.

My favorite example of saying no nicely in a letter is Abraham Lincoln's refusal to lend his stepbrother eighty dollars. This letter was written December 24, 1848, to John D. Johnston:

Dear Johnston:

Your request for eighty dollars, I do not think it best to comply with now. At the various times when I have helped you a little, you have said to me, "We can get along very well now," but in a very short time I find you in the same difficulty again. Now this can only happen by some defect in your conduct. What that defect is, I think I know. You are not lazy, and still you are an *idler.* I doubt whether since I saw you, you have done a good whole day's work, and still you do not work much, merely because it does not seem to you that you could get much for it.

This habit of uselessly wasting time, is the whole difficulty; it is vastly important to you, and still more so to your children, that you should break this habit. It is more important to them, because they have longer to live and can keep out of an idle habit before they are in it, easier than they can get out after they are in.

You are now in need of some ready money; and

what I propose is, that you shall go to work, "tooth and nail," for somebody who will give you money for it.

Let father and your boys take charge of your things at home—prepare for a crop, and make the crop, and you go to work for the best money wages, or in discharge of any debt you owe, that you can get. And to secure you a fair reward for your labor, I now promise you that for every dollar you will, between this and the first of May, get for your own labor either in money or in your own indebtedness, I will then give you one other dollar.

By this, if you hire yourself at ten dollars a month, from me you will get ten more, makinᴣ twenty dollars a month for your work. In this, I do not mean you shall go off to St. Louis, or the lead mines, or the gold mines, in California, but I mean for you to go at it for the best wages you can get close to home—in Coles County.

Now if you will do this, you will soon be out of debt, and what is better, you will have a habit that will keep you from getting in debt again. But if I should now clear you out, next year you will be just as deep as ever. You say you would almost give your place in Heaven for $70 or $80. Then you value your place in Heaven very cheaply, for I am sure you can with the offer I make you get the seventy or eighty dollars for four or five months' work. You say if I furnish you the money you will deed me the land, and if you don't pay the money back, you will deliver possession—

Nonsense! If you can't now live *with* the land, how will you then live without it? You have always been

kind to me, and I do not now mean to be unkind to you. On the contrary, if you will but follow my advice, you will find it worth more than eight times eighty dollars to you.

<div style="text-align:right">

Affectionately,
Your brother
A. Lincoln

</div>

Carl Sandburg's extensive documentation of Lincoln's life *The Prairie Years* never mentioned whether his stepbrother took his advice, but scholars assume that "Honest Abe" was effective.

The majority of my letters are joyful expressions of affection, so this book isn't about mean or difficult letters. The few mean-spirited letters I have received are destroyed and never answered. To this extent, I create my own reality: I carry on as though the letters were never sent. Unpleasant letters, like war, add to our awareness of life's tragic and gloomy side as well as the comic aspects, and remind us how fortunate we are to have sustaining, healthy, trustworthy relationships and supportive friends.

I'm on the run every minute of each workday, so organization is essential to my daily life. Consequently, for years I've color-coded everything from paper clips and file folders to coat hangers and linen-closet shelves. Virginia Woolf wrote to her friend (and lover) poet Vita Sackville-West in 1941, two months before Virginia drowned herself in the River Ouse: "I must buy some shaded inks—lavender, pinks violets—to shade my meaning. I see I gave you many wrong

meanings, using only black ink." In this somewhat subtle suggestion, Virginia W. lures her companion to read romance into the colors of ink, connoting perhaps the passions of her message.

Earlier, in the spring of 1926, Virginia Woolf wrote a letter to Vita Sackville-West, revealing the secret of all writing:

> Style is a very simple matter; it is all rhythm. Once you get that, you can't use the wrong words. . . . Now this is very profound, what rhythm is, and goes far deeper than words. A sight, an emotion, creates this wave in the mind, long before it makes words to fit it; and in writing . . . one has to recapture this, and set this working, and then, as it breaks and tumbles in the mind, it makes words to fit it.

Susan Sontag wrote a piece in *The New Yorker* about letters that makes perfect sense to me:

> I would find it easier to open my mail if all the major messages were color-coded. Black for death . . . Red for love. Blue for longing. Yellow for rage. And an envelope with a border the color once known as ashes of roses— could that announce kindness? For I'm prone to forget this kind of letter exists, too: the expression of sheer kindness.
>
> "Hello, hello, how are you, how are you, I'm well, I'm well, how are, how is . . ."
>
> "And you, my dear?"
>
> "I'm fine, my dear, in part because of my letter writing. P.S. Please write soon."

Our epistolary life reveals many truths about our hopes, dreams, enthusiasms, desires, satisfactions and disappointments. The choice of words—both used and unused—the handwriting, all tell a personal story. These fragments of experience and passion caught on the fly are sent to people one wants in one's life. How else can we stay close to those friends who mean so much? It wouldn't be practical to have all our correspondents at our breakfast table!

"Letters mingle souls," mused poet John Donne. Surely letter writing must be a part of the pursuit of happiness.

"What cannot letters inspire? They have souls; they can speak; they have in them all that force which expresses the transports of the heart; they have all the fire of our passions."

—LETTER FROM HÉLOÏSE TO ABÉLARD

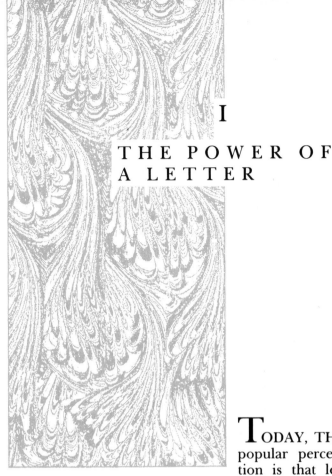

I

THE POWER OF
A LETTER

TODAY, THE popular perception is that letters are ubiquitous, old hat and banal. But the truth is, a personal letter can be one of the most intimate and touching of human expressions, *one* to *another.* A letter is a gift signature of you.

Voltaire thought of the post as "the consolation of life." A pen to the letter writer is like a brush to the artist, toe shoes to a ballerina. Unfortunately, letter writing is becoming a lost art, and letter writers are all

too rare. I believe we should all take up our pens and put them to paper! Writing may at times seem a difficult, time-consuming process because it does require a certain degree of clear thinking and focused physical effort, but I think it is far from a waste of time.

Sadly, advanced technology draws us to more sophisticated gadgets than the simple fountain pen. A high-powered business executive wanted me to design his three houses and I received daily missives of impersonal computer specifications. After several weeks of this I lost interest in the project and turned down the job. My heart melts when I get a personally written letter from a busy client. To be sure, using a keyboard with a screen and memory-programming data is attractive to a lot of people. But what has happened to the simple pleasure of the handwritten note? Is it becoming obsolete? I hope not. The power of the pen and, as the Chinese say, the long right arm have an almost metaphysical meaning in today's copy-anything, dictate-anything, delegate-everything, super-shredder society. Letters (when they aren't written by a ghostwriter) clarify for us an intimate view of another person's feelings and establish a specific point of view more real than an edited piece of prose or an invented character in a novel.

Invariably, at home as well as in the office, I flip through my stack of mail (mostly bulk) looking for the humble (yet magnificent) handwritten note. What a treat to receive a letter from a friend! Eighteenth century revived! When I do find one, I hold my treasure tightly and wait until I have a quiet moment alone before I open it. I hate to dilute the anticipation and

appreciation of someone's thoughts and feelings by facing them when I'm distracted. Someone has taken time to focus on me, even if only for a moment. I feel touched and want to savor the all-too-rare experience.

In the fall of 1986 in my book *Living a Beautiful Life* (Random House), I touched on the joys and rewards to the spirit of the handwritten personal letter. People wrote me such warm letters, it was as though we were old good friends having a conversation. Since then I have received such an enormous response to this unspectacular concept that I've decided the subject must receive fuller attention. Essentially, this book is about the pleasure of letter writing, which is at our fingertips, and the steps to be taken to achieve it. I've come to realize that letter writing is the height of true communication among human beings, especially among friends.

For most of my life, I've delighted in the letters others have written to me as well as those I've come across in literature and history books. I have read with fascination correspondence from Cicero, Ben Franklin, Percy Shelley, John Keats, John Donne, Joseph Conrad, Vincent Van Gogh, Rainer Maria Rilke, Virginia Woolf, Vita Sackville-West, Mary Cassatt, Jane Austen, Elizabeth Barrett Browning, Emily Dickinson, William and Henry James, Ernest Hemingway, F. Scott Fitzgerald, Fyodor Dostoevsky, Boris Pasternak, Colette, Edith Wharton, E. B. White, John and Abigail Adams, Henry Miller, Lawrence Durrell, Friedrich Nietzsche and D. H. Lawrence. Notes on these and other books appear at the end of this book so that you, too, can enjoy them and be inspired by other people's

letter writing. While each letter is as different as the writer's thumbprint, each letter not only exposes a slice of the person's inner emotions but also gives a historical setting that enriches the scene.

The appeal of a study of the great letter writers, according to Sir Walter Raleigh, is that it introduces us not to literary works but rather to individuals, who satisfy our innate curiosity about other people's lives and emotions.

We all enjoy reading famous letters—letters that have perhaps changed the course of history, brought peace, struck the fire of friendship, given praise, kin-

dled an idea, advised, saved the day, given thanks, declared undying love, preserved a life. I can think of a number of examples of historical or literary correspondence that I have read with fascination, but reading these letters makes me even more aware that those I personally receive and send are the most vital to my being.

I always try to answer a personal letter I receive, because for me a letter is only whole when acknowledged. The response might well be only a question, but the letter and the reply complete each other like the opposing parts of the Chinese yin and yang, in which the two opposites are one, each dependent upon the other, and their combined symbol is a whole circle. Finding a balance and center is all important in the yin-yang. The female is yin; the male, yang. The family is yin; the fierce warrior, yang. There is no beginning and no end; everything merges into one.

The tango, a seesaw ride, a tennis game, a kiss, love, all require an interaction—one to another. Letters sent and received can keep us on an even keel, centered, and can greatly increase our sense of well-being. Letters bring the world to us.

When I write a friend a letter and don't receive a reply, I find, in time, that I do begin to worry. What is wrong? Is my friend ill? In some kind of trouble? Lost on another continent without passport or credit cards? In a local jail for traffic violations? Worse? Or just overwhelmed with the hustle of the busy-ness of everyday life? I wonder.

Two lines on a pretty postcard are better than no letter at all. If you carry postcards and stamps in your

purse you can write them and send them in found moments. But we letter writers must remember that not all people are quick, avid correspondents. Their hearts may be willing but they can't find stationery, their pens have run out of ink, they can't find the words or rhythm, they fear their handwriting is illegible, they have difficulty expressing their thoughts on paper, they can't spell, they're "so busy," exhausted, discouraged, depressed, can't find a stamp or address.

One of writing's greatest virtues is the real ability to communicate deep truths and loving thoughts, but some people are willing, yet unconsciously inhibited. My dear Aunt Susie, who was raised in the Midwest in an era of great formality, said to me at lunch, "I hope you *know* how special you really are to me. I can't seem to express my love of you on paper very easily. It seems so permanent."

Many people do think their written replies will reveal the vulnerability of their souls. And, of course, they do. That is why letters are such a powerful form of self-expression.

This exposure to a slice of our inner self is something the letter writer has to suffer and accept, just as a poet or artist continuously has to uncover the truth. Once one person has entered into the dialogue of soul-baring on paper, the other should feel soothed by the opening and respond in kind. This usually happens, and a bond is formed.

Noted author E. B. White observed that a reputation as a letter writer is an entirely different kind of exposure from what he was used to as a writer of prose. "A man who publishes his letters becomes a

nudist—nothing shields him from the world's gaze except his bare skin," White said. "A writer, writing away, can always fix things up to make himself more presentable, but a man who has written a letter is stuck with it for all time." Little secrets and innuendos are revealed in private correspondence.

E. B. White died in 1985 leaving a trove of books, including a masterful selection of his letters. When writing a letter, he could be as careless as the rest of us about spelling. Bless him, he seldom corrected typographical errors. I think a professional writer should instruct his literary executor to publish the letters as they are without corrections. It is far more interesting to the reader to see misspelled words. Virginia Woolf crossed out "we're going to" in a letter and then wrote, ". . . no, I shan't tell you that: you'd laugh." Naturally, she gets our interest up with her verbal caresses. These "errors" also give us permission to do away with the letter-perfect letter. Cross-outs and misspellings are okay. It truly is the thought that counts.

A Letter of Instinct

Wendy DeFoe was my best childhood friend. She lived on Nutmeg Lane in Westport, Connecticut. We lived two minutes away as the crow flies. At 5:30 A.M. one school day, nine-year-old Wendy ran to our house, came in through the unlocked kitchen door and climbed up the stairs to the room I shared with my older sister Barbara. Wendy jumped in my bed, shook

me until I awoke and cried, "My daddy's dead."

That was my first emotional awareness of death. I had experienced painful feelings before, but not the sort of deep sorrow I felt at the realization that my best friend had lost her dad forever. I didn't know the term "sympathy letter" then, but I wrote a letter to Mrs. DeFoe explaining that I loved Mr. DeFoe, would miss him and was thinking of her. I wrote because it made *me* feel better. After all, Mr. DeFoe—"Uncle Deefer" as I called him—had always been especially kind to me; we had a close friendship. After his death I was left with the pain of absence and silence, also a welling-up of all those rich memories—those times we'd shared a slice of life together, had some good laughs. Instead of dying with him, those memories became clear and cherished in my mind as I experienced grief for the first time.

So, at age nine, I wrote my first spontaneous letter. Since then, I have come to realize that a letter written from the heart is an extraordinary gift—something that can mean much more than mere words on a sheet of paper. The gift, I've discovered, is hard to describe, but it's as much a present to ourselves as to others. In much the same way as we feel when someone gives us their affection, we feel needed and loved when we give of ourselves in writing, because we've shared an indelible piece of our souls. We've made a connection, a genuine attempt at communicating.

A recent article in the *New York Times* declared that writing letters of condolence can be "immeasurably consoling" to those who receive them. The fact that someone takes the time to write, expressing sympathy

and understanding, really helps. Experts who counsel survivors consider the notes "a critically important form of human contact." Anne Rosberger, executive director of the Bereavement and Loss Center of New York, is quoted as saying, "They want to know that the person they loved did not just vanish, and leave nothing behind." Certain mourners place a disproportionate significance on letters, keeping track of how many they received and who wrote. "Letter writers are often judged by what they have written, and that is unfortunate because some people can more clearly articulate their feelings—or what they think should be said— than others, who have just as much sensitivity for the bereaved," Mrs. Rosberger stated.

The article went on to say that the letters that recalled specific impressions and special anecdotes and memories were always the ones most cherished by the one grieving. No one wants to be told "it's a blessing" who has just lost a loved one. "I am thinking of you" soothes the best.

My friend Eliot looked sad in exercise class recently and on our way home I asked her if she was all right. She replied, "Happy died last night and I'm very sad." The next morning I dashed off a note telling her I was thinking of her. Happy was her family's thirteen-year-old dog and they loved him dearly. She was touched that I understood.

St. Francis of Assisi said, "A single sunbeam is enough to drive away many shadows." A doctor friend of mine once said, "The problem with most unhappy people is, they have never sent their ship out to sail."

Letters can be thought of as our ships. Ships are designed to *leave* the shore. There is some basis for the belief that much "shyness" and "reticence" is plain selfishness. Perhaps a lot of that has to do with lack of self-confidence. Making an effort is always difficult, no matter what your personality or circumstances, but it doesn't have to be painful. Facing a blank sheet of paper and writing a personal note shouldn't be a frightening experience. Why is it for so many? Writing the most simple thoughts, expressing an opinion, stating a few facts, sharing an observation can actually create a soothing state of mind. Remember what Confucius said: "Words are the voice of the heart."

We could learn a lesson from a child whose thoughtful note changed the image of a future President. On October 15, 1860, during the presidential campaign, an eleven-year-old girl from a small hamlet in western New York wrote to Republican candidate Abraham Lincoln expressing her concern over his appearance. She had seen his campaign photographs and was disappointed; she feared they might have a negative effect on voters in the forthcoming election. She suggested that he grow whiskers. Traveling east to Washington in February, Lincoln's train stopped in Westfield, between Erie and Buffalo. Whiskers in evidence, he asked if his little correspondent, Grace Bedell, was present. She stepped forward, and Lincoln placed a fatherly kiss on her cheek. Grace Bedell sent her ship out to sail with a message Lincoln listened to and acted upon.

The late sportswriter Red Smith used to say: "Writing is easy. Just let the blood drip down on the paper."

This is true I'm sure for some writers, but *letter* writing is giving, which should mean, for the most part, pleasure. Letters should be natural. There is no editor at the reviewing end, no rejection slip, no fierce deadline. The rewards of writing a personal letter can be enormous and lasting.

A writer friend, Paula Rice Jackson, recently told me, "More good writing is wasted in conversation." Writers reveal a great deal about themselves and their lives when they correspond with friends and relations: Letters are really conversations in which the writer is speaking, without interruption. Lettered thoughts are, in many ways, purer than spoken ones.

For example, Virginia Woolf's niece, Angelica Garrett (daughter of Vanessa Bell), suffered under the pressure of her mother's domineering personality. Even when she was married with four children, she had difficulty communicating face-to-face with her mother; it was her letters that revealed her truest emotions. Perhaps this is because all our lives we are programmed that one-on-one we must remain polite and listen. Good conversation requires a dialogue, and the tone of voice and depth of emotion are often not in one person's control. A letter writer is more apt to express a pure emotion, making marks or remarks on a sheet of blank paper uninhibited by eye contact or the reaction of the receiver, almost in a dreamlike state, in hopes of reaching the other person more honestly.

Undiluted sentiments can sometimes best be expressed in a letter. Since we aren't rushing to get the next thought out before we're cut off, we can pause,

reflect, express feelings of warmth and tenderness; declare a strong point of view, savor a triumph. Dr. Samuel Johnson observed, "In a man's letters, you know, madam, his soul lies naked."

For many people, letter writing is a tonic, a way of uplifting their daily lives. "Life would split asunder without letters," Virginia Woolf wrote in *Jacob's Room.* I tend to agree. Vita Sackville-West wrote to Virginia: "I have walked on air all day since getting your letter."

In a review of Woolf's letters, Eudora Welty wrote, ". . . these beautiful, spontaneous letters never underestimate the seriousness of experience, or betray her sense of its magnitude. What she gives in her letters comes from her awareness of the other person—the part of herself, it seems to me, that matters in the other's circumstances. This sensitivity in giving is Virginia Woolf's particular mark: it can guide her to speak from an extraordinary depth of candor." At the core

of Woolf's life, I believe, is a need for intimacy. As Welty put it: "Lightly as it may touch on the moment, almost any letter she writes is to some degree an expression of this passion." Her letters effervesce with excitement, love, hope and affection. Virginia Woolf penetrated motives and actions of people with swift and incisive intellectual and analytical power, always understanding their feelings. She wrote from the inside, expressing feelings and ideas with artistic genius.

Here are some samples of Virginia Woolf's style in writing to Vita Sackville-West:

> I enjoyed your intimate letter from the Dolomites. It gave me a great deal of pain—which is I've no doubt the first stage of intimacy—no friends, no heart, only an indifferent head. Never mind: I enjoyed your abuse very much. . . .

In another letter:

> I must stop: or I would now explain why its [sic] all right for me to have visions but you must be exact. I write prose: you poetry. Now poetry being the simpler, cruder, more elementary of the two, furnished also with an adventitious charm, in rhyme and metre, can't carry beauty as prose can. Very little goes to its head. You will say, define beauty—

> But no: I am going to sleep.

In a later letter:

You are a miracle of discretion—one letter in another. I never thought of that. I'll answer when I see you—the invitation, I mean. Oh dear, Sibyl has given me a head-ache. What a bore I cant [sic] write, except to you. I lie in a chair. It isn't bad: but I tell you, to get your sympathy: to make you protective: to implore you to devise some way by which I can cease this incessant nibbling away of life by people: Sibyl, Sir Arthur [Colfax], Dadie—one on top of another. Why do I put it on *you?* Some psychological necessity I suppose: one of those intimate things in a relationship which one does by instinct. I'm rather a coward about this pain in my back: You would be a heroic . . .

But you dont [sic] see, donkey West, that you'll be tired of me one of these days (I'm so much older) and so I have to take my little precautions. Thats [sic] why I put the emphasis on "recording" rather than feeling. But donkey West knows she has broken down more ramparts than anyone. And isn't there something obscure in you? There's something that doesn't vibrate in you: It may be purposely—you dont [sic] let it: but I see it with other people, as well as with me: something reserved, muted— God knows what . . . It's in your writing too, by the bye. The thing I call central transparency—sometimes fails you there too. . . .

In the first chapter of *Three Guineas,* Woolf reveals her belief in what letters should be: "In the first place let us draw what all letter-writers instinctively draw, a sketch of the person to whom the letter is addressed. Without someone warm and breathing on the other

side of the page, letters are worthless."

Dr. Aaron Stern, a prescient psychiatrist and author of *Me, the Narcissistic American,* believes that communication is loving. When you write a caring letter, you give of yourself. My daughter Alexandra, who wants to become a journalist, read Stern's book with such interest that afterward she made a notebook of quotes and passages to study. She shared some of these with me. "Dr. Stern," she said, "makes such good sense in a clear writing style. He's made a real impression on me."

One of the quotations Alexandra noted has become a personal favorite of mine: "There is no substitute for loving as a self-fulfilling human dimension. Our interests, our work and our skills are merely supplements to this dimension." I was reminded of Robert Louis Stevenson's observation that "a friend is a present you give yourself."

My correspondents are as varied as can be imagined: a retired bishop of extraordinary spiritual insight and intelligence, my daughter at college, an actress, a writer and editor in England, a friend in Connecticut, to mention a few. Looking at the letter writers I've enjoyed reading and those with whom I correspond regularly, I've discovered that all of them are real communicators—artists, actors, spiritual leaders, writers, and would-be poets!

One of my favorite correspondents is an eighty-five-year-old retired schoolteacher who lives in St. Louis. We have never met. Misty, the widowed sister-in-law of my mentor and friend, interior designer Eleanor McMillen Brown, is a rich source of anecdotes

and information about Mrs. Brown. I eagerly look forward to receiving her warm, chatty letters. A true correspondence has the grace and rhythm of a friendly game of Ping-Pong. Misty's last letter encouraged me to "Keep making lovely houses." My letters urge her to complete writing her family history. Where true love and concern exist, far away from competition, one is nurturing and encouraging in helping another to reach his own goals and develop his potential.

"All writing is a huge lake," says author Jean Rhys. "There are great rivers that feed the lake like Tolstoy and Dostoevsky, and there are trickles, like Jean Rhys. All that matters is feeding the lake."

Some of the greatest friendships and love relationships begin in a letter of praise and admiration. Writer Francine du Plessix Gray received a fan letter from the prolific writer Joyce Carol Oates that sparked a lasting friendship. Gray said of Oates's letter: "This gave me more confidence than just about anything else. It showed a kind of generosity, an exquisite sense of manners and orderliness." Writers facing blank paper hope and pray for soul mates with whom they can communicate and connect.

I am reminded of Robert Browning's letters to Elizabeth Barrett, in which he stated that he loved her poetry with all his heart. They had never met. Did Robert want to know Elizabeth? Elizabeth Barrett pounced at the chance to correspond with the poet, whose work she admired; the next day she acknowledged her debt to him: "I thank you, dear Mr. Browning, from the bottom of my heart . . . Such a letter from such a hand." That exchange developed into a love

poem, which is really a love letter. There is something moving about poetry sent by letter. Elizabeth's eloquent poem to Robert from her *Sonnets from the Portuguese* begins:

How do I love thee? Let me count the ways.

I love thee to the depth and breadth and height My soul can reach. . . .

And ends:

I shall but love thee better after death.

After reading the first edition of Walt Whitman's *Leaves of Grass,* Emerson wrote Whitman: "I am not blind to the worth of the wonderful gift of *Leaves of Grass.* I find it the most extraordinary piece of wit & wisdom that America has yet contributed. I am very happy in reading it, as great power makes us happy. . . . I rubbed my eyes a little to see if this sunbeam were no illusion; but the solid sense of the book is a sober certainty. It has the best merits, namely, of fortifying & encouraging." Soon after writing the letter, Emerson met Whitman, and their mutual admiration lasted the rest of their lives. I am told that Emerson left to his literary executor more than four thousand letters.

Bertrand Russell, philosopher extraordinaire for almost a century, was known as an avid pursuer of women. At age seventeen he married Alys Pearsall Smith, twenty-two, a champion of free love. In 1911 and 1912, while still married to Alys, Russell overtly

courted Lady Ottoline Morrell, half-sister of the sixth duke of Portland, with more than two thousand letters. Despite this romantic onslaught, she refused to leave her husband. At least this was better than Victor Hugo, who wooed lady after lady with exactly the same love letter.

Henry Miller received a letter of praise from Lawrence Durrell after Durrell read the electric *Tropic of Cancer*. Durrell's letter friendship with Miller led to repeated invitations to Miller to come visit Durrell in Corfu. At last, Miller accepted. As a result of this visit Miller wrote my favorite of his books, *Colossus of Maroussi*, a slim travelogue about Greece. I recently learned that this gem, published in 1941 by Colt Press in San Francisco, had only one printing of 100 copies. With incongruous pride I confess I have two copies in my library. In it Miller says of Durrell's letters: "I had been receiving letters from Greece from my friend Lawrence Durrell who had practically made Corfu his home. His letters were marvelous too, and yet a bit unreal to me. Durrell is a poet and his letters were poetic: they caused a certain confusion in me owing to the fact that the dream and the reality, the historical and the mythological, were so artfully blended. Later I was to discover for myself that this confusion is real and not due entirely to the poetic faculty. But at the time I thought he was laying it on, that it was his way of coaxing me to accept his repeated invitation to come and stay with him." Miller, away from Paris and Brooklyn, said that we generally travel to see sights and learn about foreign lands, but we go to Greece to discover *ourselves*.

Virginia Woolf believed that a correspondence could "give back the reflection of the other person." Communication is reciprocal, just like affection. If someone sends a friend a letter "out of the blue," another letter usually returns. I've written a dozen letters over several years to an English journalist who has never answered. During dinner in London last fall, he admitted to me: "I write for a living, Alexandra. I can't bear to write when I don't get paid, but I do miss getting letters from friends. Don't give up on me. I love your letters!" Frankly, my pen touches down on paper faster when I feel a response in the wind.

Letter writing is a way of thinking out loud on paper. Virginia Woolf never drafted her letters and was known to scribble one off in five minutes, never reading it through. I sense that most letter writers take real pleasure in the physical process. Edith Wharton never knew Colette except through her books and believed she was "one of the greatest writers of our time," a woman who could communicate directly to her about the subtle nature of female passion. Colette sparks the sensual delights in her descriptions of the weather, laurel blossoms, raspberries, the crinkle sound of her air-mail paper, the joy of a bath in front of an open window in spring. Wharton wrote that Colette could convey "the tears in sensual things" and she averaged half a dozen letters a day—all spontaneous, quick and abundant with sensual details. Virginia Woolf loved Vita Sackville-West's huge writing paper. I read that not only did Vita lock up her private letters but she also locked up her stationery. Once she couldn't find

the key and was frustrated because she wanted to write Virginia.

I can usually feel the voice of the person writing me, except when I receive a perfunctory letter that has no soul. I can always tell if the writer had fun in the process. Woolf's letter didn't have to be more than a few sentences to convey directly her circumstances. She was undeterred by manners or false modesty. For example, in letters to Vita:

> I've seen so many people—life offers so many problems and there's a hair in my pen.

Or,

> Yes, I do write damned well sometimes . . .

And:

> After all, what is a lovely phrase? One that has mopped up as much Truth as it can hold.

Or,

> Ah, if you want my love for ever and ever you must break out into spots on your back . . .

You don't have to be a *professional* writer to take pleasure in letter writing, any more than an artist has to sell paintings. My friend, the book editor Kate Medina, lives next door to me in Manhattan. We communicate by handwritten letters, note cards and post-

cards. We like to write because we know that the telephone is generally a rude interruption. We are always distracted, caught in the midst of doing something else, and it invariably breaks the spell of our particular activity and thought process. Kate often edits at home in a secret escape place—a converted maid's room an elevator ride away from her family, distractions and the telephone. Her work requires quiet. Since so many of us must use the telephone in our work all day, letters become welcome, unobtrusive treats we give ourselves and each other.

Letters have a way of pinpointing the moment. We tend to describe the setting, what we are wearing, the weather, what we ate for lunch, what music we're listening to, our reaction to the current political situa-

tion. Rereading old letters can remind us where we once were physically and emotionally at one very specific time in our lives. When my mother died, I discovered she had saved most of the letters I had sent her, beginning when I was nine at camp in Maine. Rereading those first camp letters, I could see myself standing in line to give the counselor a pink envelope addressed to Mr. and Mrs. Robert Powell Johns. Before being allowed to sit at the Sunday supper hall, we were obligated to write our parents. (I tried to continue the weekly communication, out of habit and tradition, until my parents died.)

As a reward for our incredible effort, the camp allowed us to select one form of nickle candy per week; we did this ritualistically after the letters were mailed on Sunday nights. No letter home, no candy. Simple. We all wrote home on Sundays! From the beginning, my letter writing had sweet associations. I always selected a variety of flavored pastel Necco Wafers—I could either suck on the candy disks the size of quarters or soak them in a glass of water overnight and make a "soft drink." I remember getting about thirty pink, mint-green, yellow, white, orange, brown and gray wafers in each package; if carefully disbursed, the supply would last until the next Sunday night.

Letters can be inspired by rewards great and small, but they also soothe our increasing thirst for nostalgia. As writer Saul Bellow put it: "Everybody needs his memories, they keep the wolf of insignificance from the door." Our lives, after all, are half memory.

All of us seek self-knowledge. Every day we come up

with new pieces in the puzzle of our lives. There are times when we are in the mood to write long, intimate letters about our feelings. In a letter, we can pour out our souls—our innermost thoughts, fears and passions—talking in *writing* to a friend, sharing fantasies and concerns of the moment. This process calms and purifies us because we have tangibly arranged our feelings in a specific form.

Sometimes, I admit, I don't send these soul-baring letters; they are really written to clarify my feelings and are more beneficial to me than anyone else. So, I clip them into my journal. When I do send an extremely philosophical letter, I sometimes keep a copy, the way I do with my other forms of writing, so I can look back on those feelings later. For this reason, I find it essential always to date letters—month, day and year. It's also fun and interesting to write your location. Colette not only told her reader where she was sitting, but she also asked the recipient how he or she liked her pen. Often I tell the time of day or include the weather (which, after all, greatly affects our mood). One friend only writes me when he is on a plane; he always puts the flight number, altitude and destination on the top of the tissue-thin atmosphere-blue paper. As I read, I can visualize his journey above the clouds as well as his final destination. Painting a scene for the reader enriches the experience.

There is so much symbolism and metaphor in letters. Sometimes we can use landscape, the way Hemingway did, to portray moral states. We can read between the lines in a rainbow of ways at a variety of

times the way Virginia Woolf and Vita Sackville-West did throughout their nineteen years of correspondence.

Handwriting, too, is subtly revealing. It is said that large capitals and long t-bars show self-confidence and enthusiasm. Last summer, in Sintra, Portugal, at a picturesque quinta overlooking an old summer palace, I met a young artist from Santa Fe. He was completing a book on handwriting analysis and asked me if he could study my handwriting. While I won't tell what conclusions he drew, he was quite accurate. Handwriting is telling.

It's unfortunate that we all haven't been encouraged to write and express our feelings. The mother of a Bolivian dictator said that if she had known her son was going to be president she would have taught him to read and write.

In his book *Half the Way Home: A Memoir of Father and Son,* Adam Hochschild wrote poignantly of his world-famous father, head of Amax Inc., one of the largest mining concerns in the world. Efforts on Adam's part to appeal to paternal edict were met with chilly dismissals; a lengthy copy of his journals, sent as a letter to his parents, was returned to him by his father edited in blue pencil for errors of grammar and style.

Many achievers have suffered from dyslexia (a reading impairment that causes sufferers to transpose letters and numbers): Winston Churchill, Albert Einstein, Nelson Rockefeller, Cher, General George S. Patton and Woodrow Wilson, to name a few. From time to time we can all suffer from this. Even President Reagan in signing the 1986 tax bill, surrounded by

senators looking over his shoulder, signed his last name first and his first name last. I know of a seven-year-old apparent dyslectic who wrote home to her father from summer camp, only to have her letter returned marked in red with corrections accompanied by a note that said, "Next time do it right." The poor girl was devastated. In fact, ten years later she still won't write letters to anyone. Imagine not even being able to write a simple note to a boyfriend because you are so afraid the hurt and humiliation will be repeated if the letter has any errors. My friend knows better in her head, but her heart tells her she can't take the risk. E. J. Phelps was right when he said, "The man that makes no mistakes does not usually make anything."

You don't have to be seven to be hurt by such rejection. We all need encouragement in order to achieve anything; criticism can chill our best intentions. If I make the effort to write a letter from my heart, I don't want to receive criticism and gratuitous advice about my expression. I'm not turning in an English paper; I'm handing over a personal confidence. Handwritten notes are not meant to be *letter-perfect.* A smudge, crossed-out words, misspellings, different colors of ink—the result of several sittings—all add to a letter's character. It's human to make mistakes. An elderly friend I correspond with from Texas told me she never rereads a letter once she's written it; she believes her spontaneity and thoughtfulness are what are intended to be conveyed, and she doesn't want anything to interfere. For those whose habit is to reread their letters, a reading out loud works well to hear the rhythm. Perfectionists, however, may reread and re-

write their letters until eventually the character gets squeezed from the words and they become polite, too neat, lifeless, and often—oh dear—never mailed. Namby-pamby "thank you for the . . ." notes written solely out of duty are a missed opportunity to make real contact with a captive audience as well as to create a little amusement.

For many years I corresponded with an older writer who had helped me in the earlier days of my struggle to express myself. He had seen me as a twenty-two-year-old young woman sitting under an elm tree near the courts at a tennis club in Connecticut, scribbling in a spiral notebook. One day he inquired, "What are you writing?" "A book," I stated. "If there is ever anything I can do to help you with your writing," he told me, "please get in touch with me. I'm a senior editor at *Reader's Digest.*" Wow!

Ten years later, my first book was published by Doubleday. During the course of that decade, I remember sending an outline of a book to him. I realize now that it was an encyclopedia of what little I knew.

But he treated me kindly. I gradually grew to feel less embarrassed and more confident as a writer, even when he was amused by the way I misspelled such words as "paraphernalia" and "onomatopoeia." *Reader's Digest* excerpted a chapter of my first book—an incomparable thrill.

How can we encourage people—some of whom have been nurtured solely by television, telephone, computers, Walkmen, rock music, cash registers and hair dryers—to calm down, be still, put pen in hand and quietly write a handwritten note? Can this almost

lost art of letter writing survive? Revive? Will young people discover, and will we rediscover, the thrill of sending a kind letter to a friend, an admirer or acquaintance?

Letter writing used to be the principle form of communication prior to 1876 and the introduction of the now ubiquitous telephone at America's Centennial celebration. Often letter writing was an art form. In today's lightning-paced, nuclear-obsessed society, we are virtually starved for the individual stamp of a personally handwritten letter. We live longer than ever before. So what is our maddening rush? What makes us "too busy" to send the gift of a letter to someone we care about? We all get caught up but too busy for what? Edgar Allan Poe taught that "Man is now only more active—not more happy—not more wise, than he was six thousand years ago."

And since handwritten letters are so rare, they become as treasured as a Fabergé egg: less than 6 percent of all first-class mail is personal and half of all household-to-household mail is greeting cards. We receive piles of mail each day, but the bulk of it is junk mail, bills and charity or political solicitations. Over 52 billion pieces of third-class mail are delivered each year. A landscaper from Indianola, Iowa, got so fed up receiving an average of ten pounds of junk mail a month that he finally replaced his mailbox with a 20-gallon galvanized-steel garbage can.

Once Virginia Woolf sent a typed letter to Vita whose reaction was worry: "I thought I must have committed some crime when I saw a typed letter from you signed 'Yours faithfully, Virginia Woolf,' but I

quickly saw it was all right, and have sent a small dona-
tion to the library.'' Apparently Virginia was an enthu-
siastic patron of the feminist library in Marsham
Street, Westminster, founded by the London National
Society for Women's Service, and she appealed to all
her friends for subscriptions.

I scan the mail for a hand-addressed envelope with
an attractive stamp rather than an impersonal com-
puter sticker on an envelope run through a postage
machine. I crave letters from someone who knows me
personally rather than someone to whom I am merely
''Dear Madam or Sir,'' or ''Dear Friend,'' a name on
a mailing list or the person who pays the grocery bill.
I particularly resent the political pitch-computerized

letters in which someone coos in the second paragraph: "And not only that, *Mrs. Stoddard,* but . . ." as if to hoodwink me into believing it's a personal letter. I received a letter recently addressed "Dear Alexandra, Let me take a few minutes of your time to tell you about . . ." Worse still is one of those anxious mailing-list missives sent Federal Express to lend urgency to the banal.

I can never receive enough *real* letters, no strings. I gobble them up, knowing full well that in time I will respond to each and every letter I receive. I have a beautiful slim eight-inch-long silver George III letter opener (formerly a meat or game skewer) with a rampant lion crest, which helps me turn my letter-receiving into a most pleasant ritual. Hemingway used a pocketknife to cut his envelopes, which he usually opened in a café. I am insatiable for nice personal mail. Real letters, written from the heart, are always a joy to receive.

Writers write. This is a fundamental truth. Most people who don't write claim they don't have time, yet writers invariably *make* time to write because to them it is a therapeutic and enjoyable priority. Many writers correspond with a wide range of people from all over the world and bring far-off places and colors within their grasp. When sitting down to write a letter, try to visualize the person to whom you are writing. What is your friend's life like at that moment? I'm stimulated by the inexplicableness inevitable between two correspondents. Virginia wrote Vita ". . . how little we know anyone, only movements and gestures, nothing connected, continuous, profound." Even a *billet-doux* is

often mysterious. A novice letter writer shouldn't try to sound like Proust, Yeats, Shelley or Rilke. Pretension, research, quotations pasted on messages, drawings and jokes are not necessary. Just be yourself: talking to a friend on paper in your own voice as if he were seated next to you is all it takes. What an exalting experience! Emerson understood that a friend is a person "with whom I may be sincere. Before him I may think aloud."

I continue to read with great interest volumes of published letters, yet a few fresh sentences addressed to me from someone alive and kicking give me more of a lift than does any published letter, no matter how brilliantly it may have been composed. One of the most appealing characteristics of a letter is its raw and earthy quality—"Dear You, I am here thinking of You now." There is a pulse, an immediacy, an electric charge that Emily Dickinson must have felt every day when the postmaster, who knew her well, arrived. I believe our most powerful talisman can be our letters.

GRACE NOTES

- Write from your heart.

- Express intimate, immediate impressions.

- Use a variety of different-colored inks and stationery.

- Buy a fountain pen and discover its magical powers. I write all my letters and books with fountain pens I've collected over twenty years.

- Read people's published letters. They're more real than biography and even autobiography because they're deeply specific.

- Just think of it: Abraham Lincoln wrote a love letter to his future wife, Mary Todd, before they began courting; at a future time the letter would be auctioned at Sotheby's by John Marion for $77,000.

- Encourage your children's letter writing by never correcting their grammatical errors and style. A letter written out of love, from the heart, should never be criticized.

- Express your understanding of what someone else is going through by sharing your thoughts. Everyone is touched by positive reinforcement.

- When you write someone to report a simple truth—that you're thinking of them—you always touch that person.

- Send your own thoughts in a blank card, rather than buying a printed card that tries to formalize your feelings. Just say it, in your own words.

- Sit by a crackling fire and read some of your favorite letters. While sitting there soaking up all the love and support, think of one person you love and write a beautiful, loving letter to that person. Let the flame in the hearth warm your heart. One letter in a lifetime to a mother, a daughter or a special friend could make a greater difference than you dare believe.

- Write a note inside each book you give away as a present.

- Press old stamps inside favorite books. When you flip through the pages, you will get a huge lift and it will bring back memories.

- Attach a favorite stamp inside a letter you send to someone else so the receiver can send it on to a friend.

- Sprinkle some perfumed dried flowers inside an envelope and send a note saying, "I'm longing to see you."

- Send a letter that has some quotations that seem to apply especially to the person you're writing. Clip them out of *Forbes,* the *Reader's Digest,* from an out-of-date calendar or send fortunes from Chinese cookies.

- Save beautiful stamps. Collect LOVE stamps. After the stamps are no longer available, use them to surprise a friend.

- Decorate a large, colorful envelope with a collage of pretty stamps. Use a variety of favorite ones that equal your postage.

- Line the envelope inside flap with some colorful patterned wrapping paper. Book and gift stores sell books of lovely shiny finished paper.

- The next time you deliver a letter by hand, use sealing wax to add a touch of nostalgic elegance.

YOUR GRACE NOTES

YOUR GRACE NOTES

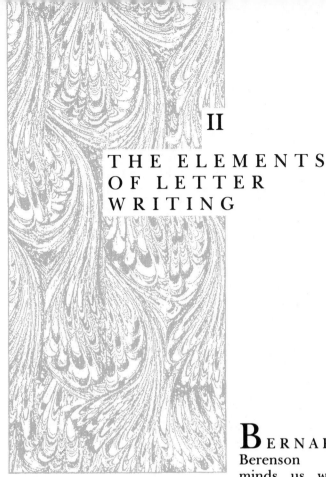

II
THE ELEMENTS OF LETTER WRITING

BERNARD Berenson reminds us what our most important asset is: "I would I could stand on a busy corner, hat in hand, and beg people to throw me all their wasted hours." Our lives are made up of time, and the quality of our existence depends on our wise use of the moments we are given. As Rodin insisted, "Nothing is a waste of time if you use the experience wisely." At least some of those dissipated hours we all know so well can be turned around into con-

tented moments of letter writing. Why is it that the busiest people seem to find the most time to communicate?

I am a great admirer of John Russell, the *New York Times* art critic. I've been told he writes an average of fourteen letters a weekend. His articulate wife, Rosamond Bernier (author of the forthcoming book *Listening to Philip Johnson*), says of her accomplished husband: "John still has that eighteenth-century habit: He just sits down and writes as he breathes." "Everybody I know writes wonderful letters all the time," John says. "It's a worldwide trait among those whom I know and like. In fact, I find that the more hard-working and generally active they are, the more they write [letters]."

Looking up at the clock on my desk, I once timed myself writing a brief note to a friend. It took me roughly four minutes, including addressing the envelope, putting on a stamp—even using sealing wax. My pocket calculator tells me that if I were to write three letters a day for one year, for a total of 1,095 letters, it would consume less than one percent of my time and cost less than one dinner for two out on the town. And if I were to skip one ho-hum TV show, I could write fifteen letters. Instead of going to a two-hour movie, I could write thirty-seven letters! Time and money are not necessarily at the root of the personal correspondence problem. The rewards so far exceed the effort that we should begin to set ourselves up for regular communication.

During the day I carry a purse that has an outside

open pocket where I keep letters, so I won't forget to mail them. For me it is behavioral science: If I have a specific pouch in which to stash my letters before going to the mailbox, I usually get them posted regularly.

People often assume that picking up the phone is much quicker than jotting down a note. However, I've discovered that it's twice as time-consuming, because half the message is diluted by the person on the other end of the phone trying to respond. It's not as hard to end a letter as it is to stop a phone conversation. Some quick calls end up being twenty minutes, the time it takes to write five notes or one long wonderful letter.

There is a saying that time is money. So far, it costs *less* to mail a letter than it does to talk on the phone. Besides, you pay up front with a letter; a phone bill comes long after you have forgotten all that discussion. But saving money is not the reason for writing a letter. Writing has permanence and requires discipline, which makes it stimulating to our minds and our senses. Whenever we extend an effort, we become aware of the mysterious workings of our brains. Writing is active. We are the creator.

One of the handful of books I try never to be separated from is Rainer Maria Rilke's *Letters to a Young Poet*. Each time I read these ten letters, I experience something new. In Letter Five, Rilke says, "For letter writing I need more than the most necessary tools: some silence and solitude and a not too unfamiliar hour." Rilke had troubled relationships. He was more

comfortable putting thoughts and his most intimate communications on paper.

"Life is difficult," Dr. Scott Peck wrote in the opening sentence of *The Road Less Traveled.* If life is difficult and we face it squarely as a struggle, solitude can be a way for us to compose ourselves and an opportunity for self-expression and satisfaction.

These days, solitude is a welcome retreat, yet we seem to have a love-hate relationship with isolation. Most of us sometimes feel uneasy about being alone. Letter writing allows us to be alone yet connected. We need a certain amount of solitude in order to have true ideas to communicate. But few of us desire solitude *all* the time. Emily Dickinson was an exception in her ability to live for thirty years as a veritable recluse in her father's house in Amherst, never to step out except for a garden walk or a weekend in Philadelphia. Oh yes, and to bake brownies. Critic Louis Untermeyer commented, "Within her four walls, [Emily Dickinson] beheld more than is ever seen with the physical eye. She did not need the world. . . ." She wrote letters, like her poetry, with "stark intensity." Her remarkable correspondence with Colonel Thomas Wentworth Higginson, a man of letters, began with a "stray note of admiration" she sent him for an article in *The Atlantic Monthly,* addressing him as "Dear Master." Emily Dickinson was thirty-two years old in 1862 when she began this correspondence; the friendship lasted twenty-four years—until her death in 1886 at age fifty-six.

When she was forty, Dickinson wrote this letter to Colonel Higginson:

Truth is such a rare thing, it is delightful to tell it.

I find ecstasy in living; the mere sense of living is joy enough.

How do most people live without any thoughts? There are many people in the world,—you must have noticed them in the street,—how do they live? How do they get strength to put on their clothes in the morning?

If I read a book and it makes my whole body so cold no fire can ever warm me, I know that is poetry. If I feel physically as if the top of my head were taken off, I know that is poetry. These are the only ways I know it. Is there any other way?

They met face-to-face on perhaps only one occasion. At Emily's funeral, Colonel Higginson read a poem on the subject of immortality by Emily Brontë, one of her favorite writers.

Through the letter writing ritual, we can make opportunities throughout our hectic days to pause, reflect, contemplate, imagine, dream and reach out in human affection and appreciation. As we think about what is really meaningful in our lives, we can respond by sharing our thoughts. Solitude makes us contemplative and receptive, more aware of life's gifts and our own special blessings.

Recently I attempted to write a letter to a close friend while bouncing along in three consecutive taxi rides going from one appointment to another. Something made me hesitate before popping this disjointed correspondence into the post. The next day, sitting still, I wrote a new, long, serious letter after I had been reading and writing for several hours. The difference between the two letters was like day and night. The letter written in the cab was unhappily choppy, in handwriting that was the result of three bad drivers discovering all the potholes in New York City. As I reread the letter it sounded frustrated, discouraged and fractured. While it is perfectly true that one of the greatest advantages of letter writing is that it can be done anywhere and at any time, a letter written during a stressful experience is bound to convey the wrong overall impression.

Rilke says, "Starting is so beautiful." I find it helpful if I set aside a few solitary moments before I begin to write. I begin by closing my eyes and giving myself time to ponder and muse. Next, I stretch my arms over my head and extend them wide on either side. I shake my wrists vigorously for several seconds and take several deep breaths, so that I can become centered and balanced. I light a scented candle and look around me.

These few warm-up exercises result in different feelings and dimensions. A friend from California wrote me a long letter after making a few notations in her journal. She had just washed her hair and was sitting alone on her terrace watching the sunset. How different her letter would have sounded if she'd written it on the run.

Is starting beautiful for all of us? As when a train begins its journey, starting requires a bursting plunge forward. When I'm running fast in an effort to catch up, I tend to procrastinate in my letter writing. I don't think I'm alone in this. However, Henry James observed, "Nothing is so fatiguing as the eternal hanging on of an uncompleted task." A bread-and-butter letter of thanks is fairly easy, especially if you do it immediately after a visit. We have a friend who hand-delivers a thank-you note so promptly that the impact is doubled. His few brief words read like poetry—sincere yet succinct. "Thank you, Alexandra, for a *superb* evening." I think sometimes we forget how much even one line can touch us. Like a pat on the shoulder or a kiss on a cheek, a warm sentence expressing appreciation is nearly effortless compared to the time and care that the hostess invariably puts into a dinner party. Sitting down to write a thank-you note doesn't mean pouring out your soul on reams of blank paper. A letter can be one or two lines long, to be savored like an announcement of a prize. Emerson knew the magic touch: "The reward of a thing well done is to have done it." To get caught up and stay caught up on thank-you notes frees you to write banter to someone else you like. My friend Whitney North Seymour, Jr.'s favorite maxim is "Do it now." The little things we all do are effortless when done at once. Instead of feeling bogged down, when something is accomplished—even the smallest task—we feel a sense of relief and satisfaction.

In his *Lecture Notes,* Abraham Lincoln warned against falling behind in correspondence; but, in fact,

we do. Shakespeare said, "Better three hours too soon than one minute too late." An unanswered letter doesn't go away. Expressing thanks is always nicest and most gracious in writing. *Everyone* is busy, so that is hardly an excuse not to write. We are all given equal time each day. It's ironic that it is often the busiest among us who are the most faithful letter writers. It's not a terrific opening paragraph to write *or* read, "I'm sorry I haven't written sooner but . . ." Better to make a brief statement of gratitude—"Great evening. Thanks."—and get it on paper and delivered, even if it's late. Even assuming certain letters are written out of duty, it's more gracious when your letters seem spontaneous and pleasant—"Dinner was delightful"—rather than petulant: "I regret arriving late for your dinner party and leaving early for my flight back to Congress. . . ." I've discovered that the really important people are generally the most thoughtful. Perhaps the personal effort they extend has led them to places of influence.

Somehow, realizing that one line is sufficient makes it much easier and pleasurable for us to respond promptly. Often, once we actually begin writing, we find we want to continue and actually run out of space on the page. You may find it's better and more fun to write letters in a place different from where you pay the bills, and of course the inspiration to be spontaneous will come more frequently when you have the necessary gear at hand. There are several significant elements that go into letter writing: If I have to get up, move around, find stationery, look up an address, locate a dictionary and the date of an event, it can

become an excuse to switch to another activity, such as stacking the dishwasher—and the spell is broken. Sitting down and quietly writing for a block of time with no interruptions can be an enjoyable, satisfying experience.

To assure happy, unfrustrated moments with pen and stationery, try to have the proper spelling of names and the correct addresses with zip codes before you begin. If you intend to write a series of letters at one sitting, you might want to address all the envelopes first. Be careful, though. Once I mixed up the letters as I stuffed them inside! Recently I wrote fifteen letters at one sitting, which put a serious dent in a new box of stationery. I never could have sat long enough to finish that many letters if I hadn't had all my information at hand as well as attractive stationery.

On that particular letter-writing session, I used sky-blue paper with hand-painted fuchsia borders and fuchsia-tissue-lined envelopes. I bought fuchsia ink cartridges so the ink matched the border. I even found some sealing wax that was color-coordinated; that inspired me to make the extra effort and use my signet ring to stamp the letters with a personal touch. Once you've made this kind of effort, choosing an attractive stamp shows panache.

I have no idea how long this process took, but the time zoomed by. I remember feeling delighted as I put the letters into the letter box on my way to lunch.

One of the most delightful letters I've ever read was a thank-you note. It was obviously a touching experience for the writer, William James, to take pen in hand and thank his Philosophy 2A class at Radcliffe College for giving him an azalea tree. James left behind a voluminous correspondence revealing a zest for life. This letter is a classic example of graciousness and appreciation:

Cambridge April 6, 1896
Dear Young Ladies,—I am deeply touched by your remembrance. It is the first time anyone ever treated me so kindly, so you may well believe that the impression on the heart of the lonely sufferer will be even more durable than the impression on your minds of all the teachings of Philosophy 2A. I now perceive one immense omission in my Psychology—in the deepest principle of Human Nature is the craving to be appreciated, and I left it out altogether from the book, because I had never had it gratified until now. I fear

you have let loose a demon in me, and that all my activities will now be for the sake of such rewards. However, I will try to be faithful to this one unique and beautiful azalea tree, the pride of my life and delight of my existence. Winter and summer will I tend and water it—even with my tears. Mrs. James shall never go near it or touch it. If it dies, I will die too; and if I die, it shall be planted on my grave.

Don't take all this too jocosely, but believe in the extreme pleasure you have caused me, and in the affectionate feelings with which I am and shall always be faithfully yours,

<div align="right">William James</div>

Just this morning, as I was working on this manuscript, my husband and I received our usual Saturday-morning phone call from our daughter Alexandra, and she thanked us for all our letters. "There has only been one day I didn't receive something in my mailbox," she said. "Keep them coming." As soon as we hung up, I took the lid off the pale blue box of stationery I bought in London last summer and began a chatty, four-page letter and enclosed a few clips from the *New York Times.* Inspired by the pleasure it brings Alexandra to open her mailbox and discover a letter, I had a delightful time chatting away to my daughter in my handwritten letter only minutes after we had spoken on the telephone. I was amazed I had so much to write about!

Letters are not always chatty messages. They can convey sorrow, too—perhaps in the most sincere and gracious way. Letters can be composed in private, re-

ceived and read in private. When an infant daughter of Charles Dickens died, his wife was away. He wrote to her to tell the dreadful news:

Devonshire-terrace
Tuesday morning, 15th April, 1851

My dearest Kate,—Now, observe, you must read this letter very slowly and carefully. If you have hurried on thus far without quite understanding (apprehending some bad news) I rely on your turning back and reading again.

Little Dora, without being in the least pain, is suddenly stricken ill. There is nothing in her appearance but perfect rest—you would suppose her quietly asleep, but I am sure she is very ill, and I cannot encourage myself with much hope of her recovery. I do not (and why should I say I do to you, my dear?) I do not think her recovery at all likely.

I do not like to leave home, I can do no good here, but I think it right to stay. You will not like to be away, I know, and I cannot reconcile it to myself to keep you away. Forster, with his usual affection for us, comes down to bring you this letter and to bring you home, but I cannot close it without putting the strongest entreaty and injunction upon you to come with perfect composure—to remember what I have often told you, that we never can expect to be exempt, as to our many children, from the afflictions of other parents, and that if—if when you come I should even have to say to you, "Our little baby is dead," you are to do your duty to the rest, and to show yourself worthy of the great trust you hold in them.

If you will only read this steadily I have a perfect confidence in your doing what is right.

<div align="right">
Ever affectionately,
Charles Dickens
</div>

Having a place *and* a variety of paper, cards, postcards, envelopes, stamps, sealing wax and writing paraphernalia all symbiotically encourage the act of putting a pen to a sheet of blank paper and *beginning* "Dear" or "Dearest" or "My Dear." If Rilke's statement, "Starting is so beautiful," is correct, certainly sitting down to a well-equipped, ordered, attractive writing table and having everything waiting there makes letter writing a more enticing, calming and spontaneous experience. I always try to have a small bud vase with at least one fresh flower placed in front of me on my writing desk for inspiration. A gardenia blossom plucked from a nearby blooming plant, one cheerful daisy, a purple anemone, a pink rosebud or a single daffodil hold great symbolic power when isolated. A flower is alive and fragile, and reminds me of both the beauty and the mortality of life. Its petals open gloriously, then gradually wither. As a daily ritual, I attend to my bud vase before I sit to write a letter even if I intend to climb back in bed to actually write my letter. I bring my little flower with me and place it on my bedside table. This habit of always having something alive and beautiful next to me as I write has brought me not only lots of pleasure but also a bit of good luck.

There is a strong aesthetic dimension to letters that goes beyond selected words and unique handwriting.

The quality, color and design of the paper used, the width of the pen nib, the color of ink, the color of engraving, the type of stationery, the sealing wax and logo used for imprinting, and the selection of stamps all tell a very personal story. These are further aesthetic and physical elements we use to communicate our feelings in a letter: the size, shape and weight of the envelope, the color, the tissue lining, the scent, the hand-painted border, the smoothness and color of the paper—all add to the pleasure of writing, receiving and enjoying a letter.

I have a friend from Memphis who sprays her stationery box with Chanel's Coco cologne so her paper smells vaguely of her. The smallest effort expended can create a lasting personal touch.

Marsha Mason writes me on her beautifully engraved paper and invariably comments on how much she loves her stationery. We select stationery to please ourselves and we only enjoy this pleasure fully when we open the lid and share it by sending on a bit of our souls scribbled on the blank page.

Letter writing as an art does require discipline and practice, as well as a sensitive eye. Horace Mann taught us, "Habit is a cable; we weave a thread of it each day, and at last we cannot break it." Mostly, writing takes practice. I believe Calvin Coolidge was right when he said, "Persistence and determination alone are omnipotent." So try writing a few letters by hand, as a discipline, as a gesture of reaching out to a friend, as a gift to the receiver and to yourself.

Practice helps make something that is potentially uncomfortable comfortable. Now I enjoy correspond-

ing so much I have a table in my bedroom that I think of as my "correspondence desk." I use it only to write personal letters, notes and postcards. Inside a tiny marbleized picture frame is a message I wrote to myself: "Write."

Also, I've put an antique brass letter holder on my white wicker desk where unanswered letters are kept. I try to respond quickly to all handwritten letters because I am always touched when someone has not only taken the time to think of me, but has also acted on it. I know firsthand what it takes. To avoid becoming overwhelmed, I often use a correspondence card or an art postcard for my reply. I remember the words of Eugene F. Ware, the nineteenth-century American historian and poet, "All glory comes from daring to begin." There is limited space on cards—just enough to make a brief, sincere connection.

Believing that variety *is* the spice of life, I tease myself into letter writing by having a wide spectrum of paper sizes and colors handy so that whatever my mood, whomever I'm writing, I have paper and cards to match. Some of us need colorful inducements. I keep a stack of art postcards tied in a satin ribbon on my desk so I can match the appropriate image to each message or feeling I have for a particular person. Pretty blank note cards inspire me to say "hi" to a friend. Sealing wax is colorful and great fun for love letters and hand-delivered notes. It adds to the exotic mystery of faraway places. Unfortunately, it gets broken up in the machines that stamp mail, so it isn't widely used. But it is still available at some stores in a variety of colors and can go through the mail if you

use an outer envelope to protect it marked "Please hand-stamp." I have a few different-colored sticks on my desk; to stamp the wax, I use the signet crest ring my husband, Peter, gave me upon our engagement, which I store in a little enamel box. The motto on the Brown crest is *Apprendre à mourir,* (Learn to die), which we impudently changed to *Apprendre à aimer* (Learn to love), much to the horror of the family.

Some people store port in a crystal decanter; I created a similar ritual with stationery. An antique wooden English box or a basket is a fun container for stationery, cards and notes. When I do purchase fine stationery, the box is invariably attractive, so I save it and restock it with other paper. A good large stationery box is sturdy enough to use as a lap desk.

Packaging has never been better than it is today. I've seen stationery packaged in large, colorful hand-marbleized envelopes which can be saved and refilled for a lifetime. I've seen marbleized letter racks and stationery holders that are pretty enough to dress up even the most ordinary writing desk. The first time I saw paper being hand-marbleized was on a sun-filled day in Florence at Il Papiro. The decoration method of the paper is called *papier à cuve* and some say it dates back to the twelfth century. I watched artful oozes of ink being whipped around to create unique permutations of color and design, no two designs of which are alike. A few years ago, friends opened Il Papiro, a remarkable store in Manhattan, at Seventy-third Street and Lexington Avenue and now there is a branch at Battery Park City. I buy empty marbleized boxes there which I fill with correspondence and stationery. Stationery or accessory stores in your area may carry similar boxes.

The best way to maintain the necessary supplies for letter writing is similar to that for buying clothes. Your stationery wardrobe can be built just as you build your clothing wardrobe: always be on the lookout for fun and desirable items and never run out. If you continually add to and upgrade your stationery wardrobe, there will always be a wealth to choose from. Often you will be able to buy quality paper without overpaying. There are times, though, when we're willing to pay whatever the price may be for a luxurious box of stationery. For example, last summer when Peter and I were in London, we headed straight to the wonderful English stationer Smythson of Bond Street to stock

up. I found Nile-blue paper with a pink-and-red double border and matching envelopes lined in fine red tissue. The blue box it came in will give me pleasure long after the paper has been sent away. In the meantime, I'm enjoying the process of writing on this luxurious electric blue.

The indulgence, as I mentioned earlier, can be appreciated by both the giver and the receiver for many years to come. I am also enjoying Crane's hand-bordered, watermarked letter paper with their lovely lined envelopes. The backs of the envelopes are often bordered on the flap.

Since stationery is no passing fad with me, I've searched stores all over the country and throughout the world for the most interesting paper, color combinations and packaging ideas I can find. I've developed a habit: When I come to the last sheet of paper and envelope of a certain beloved stationery, I save it. After thirty years, I'm the proud owner of a special one-of-a-kind collection.

Cecil Beaton designed some breathtaking stationery in the 1960s. While most envelopes today are lined with gossamer tissue, Beaton lined his envelopes with shiny, bold colors on sturdy bond paper. One design featured an embossed butterfly on the upper left-hand side of the silvery-toned writing paper and a shocking, shiny, mottled, cantaloupe-colored lining.

One of my favorites was iridescent white with two bands—one red, one blue—across the top and bottom and the same colors in a glossy envelope lining. (One thing to remember in your search: The post office raises the rates for first-class letters that weigh more

than an ounce). Oversized paper might cost a few pennies more to send through the mail, but it's worth it.

In Paris last summer, while Peter was working on a law case, I visited our youngest daughter, Brooke, who, with her friends, was studying French and art in Paris. A friend from California arranged to be there at the same time. We spent carefree days together visiting museums, having al fresco lunches in magnificent gardens and enjoying the luxury of the wonderful shopping possible only in Paris.

Brooke has inherited my obsession for quality stationery, and my friend's father has spent his life in the paper business. Consequently, one of our most joyous

outings was a pilgrimage to Marie-Papier, a little stationery shop on the Left Bank at 26 Rue Vavin. The two small store windows tantalize passersby with displays of letter holders, stacks of colored paper bound with two-inch-wide satin ribbons, little notebooks, long sticks of sealing wax, envelopes of all shapes and sizes. We paused before throwing open the Moroccan blue lacquer French door; the pleasure of anticipating the delights within doubled our pleasure. We all stocked up; although New York has a sprinkling of their wonderful things, nothing matches going to the Parisian source.

Marie-Papier has some of the shiniest, smoothest, most delicious paper available. As we moved around the tiny shop gathering treasures—loose sheets of lined paper, notebooks, pads, writing cards, pastel note cards with contrasting pastel envelopes, long sticks of sealing wax, pastel-colored labels, postcard holders, whimsical pencils, file folders, small shopping bags, portfolios and pastel journals . . . we were giddy at the thought of one day sharing them all.

Our morning excursion to stock up on these exciting paper supplies was exhilarating. I have many friends who get the same kick from going to their favorite card shop to buy cards with printed messages that express what they want to convey. Irvine Hockaday, Jr., the president of Hallmark Cards, was quoted in *Forbes* magazine stating, "It is hard to find any business with the profitability of greeting cards." I know people who collect these cards the way I collect art postcards and stationery, and they are able to select the perfect card for the person and the occasion.

Americans purchase *seven billion* greeting cards a year. The heaviest volume of mail occurs at Christmas time, when two billion, two hundred thousand cards are sent out. At Valentine's Day, Rosh Hashanah and Easter many hundreds of thousands of cards are also sent.

Buying a card with a preprinted message *is* a whole lot simpler than facing a blank sheet of paper, and card companies have good writers who have researched what sentiments we want to express. The variety is bountiful and for everyone who really enjoys card sending, the gesture will always be appreciated.

By adding an additional message in your own handwriting you can make the card personal and special. A card shows an effort and is something fun to receive and save.

When the creative urge strikes, it's fun to design your own writing paper. A letter or note can be as lovely to look at as it is luxurious to read. Cut wallpaper samples or marbleized paper into geometric or abstract shapes, then write on the back. Make your own matching envelopes. Cut out art pictures from old magazines and glue a sheet of plain paper on the wrong side for your message. Mix and match different-colored and patterned stationery and note cards for variety. Japanese origami paper in a rainbow of intense colors can be used for quick notes. My daughter Brooke once made an envelope using a road map of the mid-Atlantic states. "I wanted my friend to know how to find me," she explained with a chuckle. I once received a colorful letter from a friend who had cut a window in the top left-hand side of a red enve-

lope: she wrote the letter on blue paper and used the letterhead on her stationery for the return address. For Christmas this year Brooke made me marbleized envelopes and marbleized borders on correspondence cards.

We all know that the true pleasures in life aren't necessarily bigger, louder, more expensive or more complex. Still, we often have to remind ourselves how refreshing, humble and useful wonderful little things can be. I have a bottle of blue ink on my desk I've had for at least eight years. It's hard to use up a bottle of ink writing brief little notes. The price is still on the bottom—89 cents. Paper lasts a long time, too. Some colored paper fades and some yellows a bit, but that adds to the mysterious aura that saved letters acquire.

I inherited my love of paper from my mother and have passed it on to my two daughters. My husband, Peter Megargee Brown, comes from a family that owned some of the early mills for the manufacture of fine paper of the kind we enjoy today. These mills were located along turbulent tributaries to the Schuylkill River in Philadelphia and were known as the Megargee Mills.

Brooke, Alexandra and I use pastel-colored French file cards for research and quotations. When paper is that smooth, the pen seems to glide across the cards effortlessly, and writing becomes pure joy. When I decorated a house in Paris several years ago, I became addicted to French paper products. We are now hooked on the French graph paper of pale lilac gridded squares against pure white, butter yellow, atmosphere blue, mint green and, of course, peony.

Plain French 4 × 6-inch file cards are ideal to use as correspondence cards and are very economical. I find it great fun to paint acrylic colors on the borders of white French file cards; it adds a personal touch and gives me an excuse to dabble with color. The irregularities can be charming—they are so obviously done by the writer's own hand.

Imprinted Stationery or Plain?

So many people are confused about the etiquette of stationery that they give up and don't write at all. Stationery is experiencing a new popularity, however, and on the average people are buying twice as much as they did a few years ago. Paper is one of the most fun parts of letter writing and should never be cause for intimidation. When in doubt, write on anything handy. One of my good friends and I corresponded regularly, usually finding time when we were on the fly, and often I'd receive letters from Martha that were written on sheets ripped from a tiny notepad. Before considering which stationery to use for which occasion, look at a list of the different occasions when you'll be writing letters. Then you can quickly see at a glance when you want to use your best personal engraved stationery and when you can be less formal and more imaginative:

Congratulations
Thank You and Appreciation
Introduction of Another Person

Recommendation
Seasonal Good Wishes
Fan Letter
Resignation
Condolence
Friendly Business Letter
Letter of Agreement
Query
Party Invitation
Fund Raiser
No Thank You
Note of Apology
Complaint
Chain Letter
Letter to the Editor

Engraved stationery is the ultimate for letter writing. Nothing is nicer. Engraving is most elegant when done on a quality paper made from 100 percent cotton.

While engraved stationery is the ultimate, it is not necessary or even the most fun for all occasions. If you write a lot of letters, you may want to use a plain paper that you enjoy for some occasions. Make your decision a personal one. The importance of the letters and your personal feelings should determine your choice of stationery.

Whether you choose a sheet of plain paper from a pad or an engraved, hand-bordered sheet with a Crane watermark, your selection should reflect the purpose of the correspondence.

All my engraved stationery comes from Tiffany &

Co. Mr. Kenneth M. Rhoads, Jr., has been there as long as I can remember and is always helpful when I order and reorder personal and business stationery. Crane's has always manufactured Tiffany's paper. Tiffany started as a stationery store in 1837. While there are many different patterned papers, the one most often used is a kid finish that has no pattern or design except the Tiffany watermark when you hold the paper up to the light.

The stationery I use most often is personal cards 3¾ inches tall × 5⅛ inches wide, made of very smooth white parchment paper, and they are engraved in geranium red with "Alexandra Stoddard" and my logo swan blind-embossed at the top. Sometimes I have my address put on the bottom right, but most often I order the cards with just my name and the swan crest. Peter has the same personal cards with his name in black. We use them interchangeably for social occasions and business notes. This size is ideal for a thank-you note, a gift enclosure, and as a note attached to a clipping. When I want to write more than a few paragraphs, I use a larger sheet.

Many people who seek to individualize themselves in this increasingly impersonal world do so by personalizing their stationery. Contrary to what you'd think with the telex, fax and telephone, writing letters by hand is a growing art.

Suit your taste and sense of style when making a selection. You can use your name or your name and address. Few people use just their address (referred to as "house stationery") but some still do. Anyone in the house can use it, and if you have a guest room

it is a nice touch. If you have a house that has a name you might put the name of the house above the address and you and your spouse can share the same paper.

The biggest change in stationery is that fewer women are using Mr.-and-Mrs.-Husband's-Name paper. Many women these days prefer to use their own first name, so they have their own paper engraved with just their name. I've never seen the virtue of "Mr. and Mrs." expensive engraved paper with a diagonal line crossing out the "Mr." or the "Mrs." You either use your less formal paper or your most formal paper, but putting a line through a name seems odd to me.

Most women like their name monogrammed on the paper, and their address engraved on the envelopes. A spouse can share envelopes if his personal paper is the same size.

There are many different paper sizes, ink colors and monogram styles from which to choose. The most popular size for a thank-you note is 4 × 6 inches. Many women choose matching single sheets for longer letters to fit the same envelope. Your monogram and your colors should reflect your personal taste. Of the many colors that are available, my favorites are royal blue and geranium.

In addition to monogrammed notes, I also order correspondence cards with several different-colored borders—yellow, geranium, royal blue—and have my swan crest engraved in the same color. They're wonderful for invitations and to say thank you. Once you have your die on file, you can change color easily when

you reorder. Women seem to tire of their stationery more often than men—I suspect because they use it more. Men are apt to use their business stationery for most of their social correspondence.

When I started my design firm in 1977, I went to see Walter Hoving in his office at Tiffany's (he was then president). I told him I wanted my business stationery to appear personal and have great style. I had no fancy office, so my stationery had to represent my company's image. Mr. Hoving looked up from his desk and smiled. "When Billy Baldwin started his design business he came to me too," he said. I was touched and I showed my personal sketch to Mr. Hoving and he liked it. Tiffany's had it displayed under glass on the main floor for years, I remember.

Going through the stationery books at Cartier, Tiffany's or Dempsey & Carroll for the first time can be frightening if you don't have a clue about what you want or need. If you go to Tiffany's in New York, ask for Mr. Rhoads and he will help you make the right choices. Try to bring with you, when you go to order engraved paper, some stationery you like, some different styles of lettering, colors and quality of paper.

Build your own stationery wardrobe. I've bought stationery all over the United States, and in Paris, Florence, Copenhagen and Stockholm. The more variety, the better. There are no rules to follow, no color codes to know. Gather what appeals to you as you go along. Study the shape, size, texture and feel. Choose what you like best.

Some stationery comes in pretty boxes, and packag-

ing can be an important element when selecting stationery. After all, we should be able to enjoy the boxes too. The prettiest, most imaginative packages are portfolios containing gift cards, plain sheets and correspondence cards all beautifully displayed and tied together in ribbons; these are excellent to toss into your tote bag when you are traveling. Airlines don't always provide stationery anymore and in this way your letters and notes can convey your personality wherever you go. Dempsey & Carroll and many other stationers have a variety of these portfolios.

Your Pen

But what good is paper without a pen? Buying a fountain pen might have been one of the best investments of my life. Writing is infinitely more satisfying when I use a fountain pen. The pen becomes a real extension of my arm, hand and heart. I get a thrill just hearing the squeak of my pen dashing across a blank page. When I'm thinking of what to say I often hold my pen close to me and I can actually smell the ink, which has the scent of harsh soap. For me, the clicking of a computer or typewriter is just not the same.

Once you've broken in a fountain pen with the right nib and it begins to respond to your writing, don't let anyone else use your pen—it will conform to your writing just as a hat or a pair of shoes does to your body. Several years ago I was revising some drawings with an architect, and he grabbed my pen to make a sketch on a blueprint for clarity. After the meeting, as

I was writing a list of what we had discussed I discovered that my pen didn't work. Someone else had used it; the ink didn't flow evenly and the nib was scratched like a key that is stuck in a door. I've learned to carry a spare Pentel pen to lend to others. How often we are asked, "May I borrow your pen for a minute?" I'm happy to say, "Here, keep it."

Giving a fountain pen to a friend as a gift is a marvelous gesture. Writing with real ink pen can become an addiction. Like Anne Morrow Lindbergh, I can't think without a pen in my hand and am happy to be paired with such a useful tool. I've gathered more than one fountain pen over the past thirty years; in fact, I collect them. Even lying unused, my pens are symbols of endless possibilities. They are an extension of my soul. After we had received good news last summer, Peter bought me a black Waterman Centennial pen and five packages of different-colored ink cartridges.

Because I'm on the go so much, I use an assortment of different-colored ink cartridges for most of my fountain pens—South Sea blue, navy blue, black, red, violet, lilac, brown, green. It's fun to use red ink on turquoise paper or green ink on white paper with yellow borders. I love the variety; the more color combinations I discover, the happier I am. I carry extra cartridges in my purse; I often begin a letter in one color and end with another. When I travel by plane, I try to keep my pens vertical so that no ink leaks; and, when I remember, I remove the cartridges of the pens that I'm not using in flight. And since I've had some unfortunate ink stains over the years, I now use washable ink.

Unreadable Handwriting

 Writing is a form of communicating. Even with the finest pen, if your handwriting can't be read you might be tempted to let the ink dry up. There are hundreds of people who feel their handwriting is illegible, and therefore they don't write spontaneous notes to people or they use a typewriter. Yet the handwritten letter or note reveals character and personality and is a delightful form of communication that should not be abandoned. There are several people I correspond with whose handwriting is uneven and hard to decipher, but I always enjoy figuring out an awkward sentence or two and am touched that the letter is handwritten. Even a warm, intimate letter that is typed makes me suspicious it might have been dictated, which dilutes some of the thrill.

 If your handwriting really is unreadable and you want to be able to dash off a spontaneous note on a

postcard or write a letter to a friend, I have a solution: PRINT. Temporarily abandon your script and practice printing. You will discover that when you print you are careful to form each letter accurately. Many people's handwriting isn't script, but a form of printing. The best advice I can give anyone about their handwriting is to write a lot. The old saying "practice makes perfect" has a grain of truth to it; while you aren't seeking perfection, you are interested in communicating well and the more you put pen to paper, the more control you have with your pen. Possibly you should begin slowly. If you are accustomed to using the typewriter and you want to pick up a pen, write a shorter, more thoughtful note so you have time to enjoy the process.

Most people who want to write personal notes in longhand can improve their handwriting within a month. It is possible you haven't really concentrated on your personal style of penmanship or really thought about developing a pleasing hand before now. It is never too late. Doodle and practice. Begin with your signature. Like learning another language, start with a few words. Write "I love you" a few dozen times until you see your best style emerge. Remember, handwriting is far more intimate than what a machine translates. A typewriter is like a printed page in a book. A personal note or letter is for one person only, written by another person. Even if you can type faster than you can form legible words on a page, that shouldn't be your most important consideration. When you become comfortable exposing your handwriting is when your writing is probably legible. Even if a friend misses a word or two, the general mood, tone and drift

can always be interpreted and you might be amazed to learn how clever people are at figuring out the meaning of your letters.

Daily Inspiration

I enjoy inkstands. I have a fountain pen on my bedroom desk that I dip into an ink pot for the private times I sit and write a letter. Just having ink in a well on my desk gives me a sense of permanence and order.

But the best equipment in the world can't make you into a letter writer if you're not motivated to perfect your skills and talent. Jean Jacques Rousseau said, "However great a man's natural talent may be, the art of writing cannot be learned all at once." Vita Sackville-West wrote to Virginia Woolf, "For however many resolutions one makes, one's pen, like water, always finds its own level, and one can't write in any way other than one's own." I think it's a myth that "educated" people know how to spell. The truth is that writers, professors and chief executives know the value of having a dictionary within reach, wherever they are. I even keep a pocket dictionary in my tote bag for letter writing when I'm away from my desk. It's also useful to have at hand a thesaurus and that slim, 4 × 6-inch marvelous sourcebook *20,000 Words Often Misspelled,* published by McGraw-Hill. To enhance the appearance of a dictionary or thesaurus, I turn the jacket inside out and cover the front with a favorite floral scene or painting clipped from a magazine. I glue (using rubber cement) a vertical 4 × 6-inch art

postcard on the front and back of the inside jacket of my little misspelled words book. These special touches help make the necessary, useful letter-writing equipment more personal and appealing.

Stamps

"Details," the late fashion designer Perry Ellis would say. Ellis always wanted special touches. For a fashion show invitation, after much deliberation he finally settled on an orchid stamp. When Ellis learned that his local post office was sold out, he made his public relations office call every post office in New York and, when that failed, beyond, even to Red Bank, New Jersey. The firm sent someone out there to buy 750 orchid stamps—twice as many as they needed—because Perry didn't like two out of four of the orchids in the series.

Stamps are a poor man's art collection. I never have had a great deal of money to spend, yet I've had enormous fun collecting things a few coins could buy. It's nice to be reminded you *can* buy beauty! I adore attractive stamps (it's amusing that boring, colorless ones cost the same as beautiful ones). I have several favorites I've collected for years: a monarch butterfly, Indian art, wildflowers, camellias, lilies, a Hokusai painting, Edna St. Vincent Millay, Edith Wharton, Architecture USA, "Letters Lift Spirits," "P.S. Write Soon," "Letters Mingle Souls," "LOVE," "Learning Never Ends," "Calico Scallops" and each state's bird and flower. I enjoy buying commemorative stamps when they are issued and feeling nostalgic about them years later.

Whenever I go to the post office, I buy a generous supply of stamps to minimize the number of times I have to stand in line. Instead of settling for a roll or a book of ordinary stamps, I always ask to see the sheets of commemoratives. I carefully survey the available selection and choose those that are most appealing to me, as well as those I think will appeal to my corresponding friends. One year's stamp commemorating "Folklife" featured a beautiful red patchwork quilt. This was perfect for letters to my friends who collect quilts; I even used it to notify one friend of a quilt exhibit. You can buy commemorative stamps at the philatelic window at large post offices. The post office issues on the average fifteen different commemorative stamps every year, and with each visit you usually have a choice of four or five designs.

The letter once sent for three cents is now twenty-

nine cents, and some of the old stamps are amusing to use today. When the spirit moves me, I create a collage of old stamps on an envelope for someone I know will appreciate the memories it will conjure. I'm sure it causes a smile. If I send a letter to a special friend in Massachusetts and use an old twenty-cent Massachusetts stamp, I might supplement it with an old LOVE stamp, a rose or an orchid. Stamps to me are much more than postage; they can be works of art in miniature and they can convey love and tenderness. (That 1982 LOVE stamp was the most popular ever issued. Twelve million were sold in New York City in just three days!) When Texas celebrated its sesquicentennial and issued a special Texas stamp, I got a real kick sending it to Texans who had moved away; it reminded them that I remember their Texas connection.

At the office, I keep my stamp collection in a small old locked wooden box. Often when I'm using stamps for effect I'll put on too much postage—I figure that a few extra pennies for the postal service is a good thing. There are so many ways we all inevitably throw our pennies around; sharing my special stamp collection somehow doesn't seem wasteful. I like to think some of the envelopes with pretty stamps have escaped the wastebasket and are tucked inside books or desk drawers for someone to happen upon unexpectedly.

William James was so right when he said, "As long as there are postmen, life will have zest." One of the joys of letters is that they aren't received on any set schedule. Going to the mailbox and discovering an attractive hand-addressed envelope gives an unex-

pected lift. The mere presence of a personally addressed envelope is powerful. To enhance the experience for others, add special treasures to your letters: insert a pressed flower, sprinkle in perfume, or some sand collected from a recent beach vacation. One friend keeps a recent batch of photographs of her new baby in her stationery drawer so she can slip a picture in with a note or letter. Friends want to "see" what's going on in your life. When writing your Christmas thank-you notes, add metallic confetti; the sparkling colors add glitter to even the grayest day. One word of warning: everyone will complain but never mind, it will give them a lift even if they have to get out the vacuum cleaner!

A letter is magical. Just think, we can put an addressed, sealed, stamped envelope in a postbox and it will reach someone *anywhere* in the world. This is a miraculous reaching out, a connecting link. Some people consider the telephone an amazing invention, but, in most cases, I'd rather receive a letter than a phone call.

I remember years ago receiving a telephone call out of the blue from someone I admired greatly, but after eight or nine minutes our talk was all over. I had been caught off guard with the ring, ring, ring as I was peeling carrots and preparing for dinner guests. After I hung up, I walked away from the kitchen phone feeling a bit empty. I was deprived of a rerun. I could try to savor the memory, but it wasn't something I could touch and hold onto throughout my life. It was rapidly fading dream. I still have memories of our conversation, but they have become foggy, unquota-

ble, and murky with the "inescapable inroads of time," to use a phrase by W. H. Auden.

Is taking notes, then, the best way to handle the telephone, even with our most intimate and personal calls? That's not the same, though the words are transcribed in our hand on our own paper. It's half the experience, somehow. But I can physically hold a letter in my hand, examining the words *and* the handwriting, rereading as often as the spirit moves me, keeping my tangible symbol forever. That's a powerful difference.

I use the telephone when necessary—to discuss business, make and confirm appointments, check up on a friend—but I let the ink flow from my pen when I want to really connect with another human.

"One of the deep secrets of life," Lewis Caroll reminds us, "is that all that is really worth doing is what we do for others." Perhaps that is why letter writing is such a centering, peaceful experience.

When I sit at my desk and write a letter, I am focusing my attention on someone else. It is as if I am pulling up a chair to have a heart-to-heart conversation with someone stimulating. It's easier to communicate because the rest of the world is edited out; I see life for a brief moment with another individual. We are together as I write. I'm certain my blood pressure goes down when I sit quietly, pen in hand, writing to someone I care about. Frustration vanishes. Writing a letter to a friend creates a calming effect and invariably lifts my spirits.

GRACE NOTES

- Write an "ongoing letter"— one written in different snatches of time. You can even use different-colored inks to reflect your moods. This will give the recipient more reading pleasure.

- Write a loving letter out of the blue, to someone you haven't seen in a while.

- A George II silver treasury inkstand by Paul de Lamérie was sold at Christie's in London in December 1988 for a million, four hundred thousand dollars.

- Collect U.S. commemorative stamps. "They're for fun, they're history, they're America."

- Buy a Cross fountain pen and receive a lifetime mechanical guarantee.

- Leave a strip of LOVE stamps on your desk to inspire you to send a note.

- Keep your stationery box open; it makes starting so much easier.

- Address your envelopes and stamp them before you begin to write your message so you have a pure, burden-free time.

- It costs roughly the same to send a letter as it does to make a short call in a public phone. A postcard costs less than a call.

- Send your pens to Miran Pen Repair's Mr. George Daly (2537 Sixth Avenue, East Meadow, New York 11554, 516-826-6084) and he will make them new again.

- Try to send a handwritten note after a business lunch just to say you enjoyed it. Messengering it that day adds impact.

- Sprinkle some dried flowers into your envelopes.

- Write a letter on the back of a pretty picture.

- Always put the day, month and year on your letter.

- Sit up straight at a desk so the muscles in your wrist and arm work to help the flow of words across the page.

YOUR GRACE NOTES

YOUR GRACE NOTES

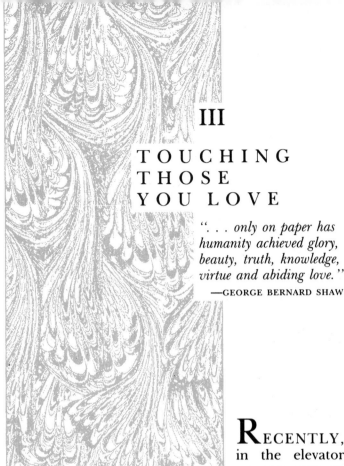

III

TOUCHING THOSE YOU LOVE

". . . only on paper has humanity achieved glory, beauty, truth, knowledge, virtue and abiding love."
—GEORGE BERNARD SHAW

RECENTLY, in the elevator on my way to work, I noticed a pretty five-year-old girl. She was wearing a ruby-red wool coat trimmed in red velvet with a matching bonnet tied in a bow under her chin. From under her hat shone spun-silk blond curls. Mittens dangled from wool strings in the sleeves of her coat. Her left hand held tight to her mother's; in her right hand were five white envelopes. I asked her if she had written me a letter. She smiled hesitantly and said,

"No, because I don't know your name yet." I quickly replied, "My name is Alexandra. Please write to me." I looked down at the five missives in her hand and saw that the stamps were creatively placed at the top left-hand corner instead of the usual right-hand side; the envelopes bore colorful pictures—flowers, trees, birds, balloons and hearts. The little girl (I learned her name was Prudence) had a flower painting waiting for me upon my return home that afternoon; its only words were "Alexandra," "Prudence" and "Love" placed at random among tulips, daffodils and daisies. Now she and I correspond.

I haven't stopped thinking of that little blond girl who captured my heart. Who knows? She could turn out to be as devout an epistoler as my Aunt Betty. During her life, Aunt Betty, an international social worker, corresponded with more than five hundred people all over the world. She never married, but Aunt Betty was part of hundreds of families worldwide who dearly loved her. I lived with my aunt while I was studying design in New York, and I observed the meticulous habits she performed with ritualistic fervor. She got an early start each morning at her desk. Sipping her coffee in the stillness of the opaque light, she sent off loving words to people everywhere—a note to a student at boarding school who was beginning a new semester; a card consoling a friend whose mother had died; a letter encouraging a young medical student in Rangoon to apply for a scholarship at Stanford University; a card to one of her twenty-two godchildren; a postcard to fourteen-year-old Ayanna, whom she had met in a youth hostel in Madras, India, encourag-

ing her to continue to work hard so she could attend school in England; she sent some art postcards to her Radcliffe College roommate recommending an art exhibit at the National Art Gallery in Washington, D.C. The list went on. Aunt Betty never got up from her desk before she had communicated with at least eight people. I've seen her finish twice that number of letters; she had a quick pen and also a certain vision and sense of mission in her correspondence. Without exception, the signals were encouraging, full of hope, enthusiasm and love.

In 1959 my cousin Betty (named after my aunt), my oldest sister Barbara and I went around the world with Aunt Betty. During that trip we met many of the five hundred people she regularly corresponded with! It was an unforgettable experience that taught me the power of the post.

"I celebrate myself, and sing myself"
—WALT WHITMAN

My greatest inspirations come when I'm at the beach, at the water's edge, and I'm aware of all my senses. The wind rustles through my hair, the sun warms my near-naked body and the light intensifies all the colors around me. As I wriggle my toes in white sand, I pause and question. Through touch, sound, taste, smell, sight and also thought, I savor paradise under a sky dusted with cotton-puff clouds.

Not surprisingly, I often write my most meaningful letters when I am isolated at a beach or cabin, when I have the luxury of time to ponder in utter leisure the

larger meanings of life and love, uncluttered by the details of daily life at home or by the constant harassment of the telephone. Usually, several days of a vacation pass before I'm rested enough to surrender to the mysterious rhythms of the waves pounding against the shore and the sense of calm the seashore or lake brings; then I settle down and begin to write. I inevitably daydream and contemplate my life, thinking of those people who have loved and nurtured me.

Peter and I were visiting friends at Cape Cod during the summer of 1982. Our host and hostess are good friends of Joan Brady, a brilliant watercolor artist. Joan invited us over for Sunday brunch where I saw her paintings for the first time. It was on that day that she introduced us to the book *The Road Less Traveled*, by Dr. M. Scott Peck. Joan pulled a paperback copy from her shelf at brunch and inquired, "Have you read this?" The book was unfamiliar to me, so I jotted down the title in my pocket notebook. When Peter and I returned to New York, I bought the book and read it immediately. Peck's book is a new psychology of love, traditional values and spiritual growth. We have since given it to more than a dozen friends.

A Letter Is a Gift
We Give Ourselves

Writing clarifies our thoughts and enables us to learn more about ourselves, our emotional lives and what we really want and care about. Because we can-

not feel integrated without giving of ourselves, it helps us feel better about who we are when we make the effort to reach out and connect. Letters help us reach others. A character in E. M. Forster's novel *Howard's End* yells, "Only connect!" The psychoanalyst Erich Fromm writes, "Reach out, unite." We are incomplete if we don't share our uniqueness with others. "Loving oneself is nice . . . but incomplete," Judith Viorst says in her book on the human condition, *Necessary Losses.*

Why do we feel so good after mailing our thoughts? Why is it so cleansing? Often I meet a friend who shares that satisfaction with me: "I've just written a really good letter." I believe "a really good letter" is a truthful letter, written from a vulnerable heart. It is

soul-baring. Because of our appetite for more per-sonal awareness and a deeper understanding of our-selves, I believe we yearn to be part of our fellow travelers' journeys. By reaching out, we have a sense of other human beings' presence in our daily living; each person we open up to and connect with reveals to us just how much time we really have each day for genuine loving relationships. All the fears of becom-ing vulnerable vanish once the rewards of deep and lasting friendship are realized. The only loss is in not trying to ignite the spark of emotion in others.

While I would love to receive a letter in return for each one I send, I have written to people I knew couldn't or wouldn't answer my letters. As with most things in life, I only regret the lost opportunity, the things I haven't done. When I learned that my art teacher from boarding school, Phyl Gardner, had slipped into a coma, I wrote to her every day. Phyl was largely responsible for my following my instinct to become a designer (although my mother and god-mother had both urged me on from birth, I needed the encouragement and confidence of an "outsider" to pursue a career in the decorative arts field).

Perky Phyl was an Englishwoman with a smile that could melt ice, a sense of playfulness and love of beauty that made her eye so discerning she could in-spire even the most lackluster teenager. My awareness that she would never see another sunset, never make another entry in her sketchbook, never see another flower, never have even one more giggle, created in me a need to give her some of my overabundance of youthful living. Phyl's nurses read her my letters. I

sent pictures of my interior design work; I shared my family life, my busy career and my reminiscences of the times she and I had spent together—the time she chased me all over the living room of her Northampton, Massachusetts, farmhouse with a blue seltzer bottle; the time we picked flowers and vegetables in her garden and she popped a soil-spotted carrot right into my mouth; all the times she'd invited me into her studio while she painted. (She always had fresh supplies for me to play with: "I come to my studio to play, dearie! Let's play!")

The nurses loved my letters because through them they could see the vitality, zest, curiosity and loving nature of this now motionless little lady. When I called, they felt they knew me. I never told anyone at home that I had written to my beloved art teacher, yet it never occurred to me that it might be considered a bit odd. I did the only thing I could do to deal with my pain.

Fifteen years later, when my mother was dying from cancer, she sat up in a chair in her hospital room one morning, commented on the peonies on a nearby table, put her head back and slipped into a coma. I left the room, ran to the elevator, raced to get out of the hospital and cried my heart out. When my dear Aunt Susie asked if there was anything she could do, I gulped out, "Bring some pretty flowers." That afternoon, the room was in peak blossom. I now realized how much Mother would have enjoyed those flowers, how much her nurses and family and ministers did appreciate them and how much they helped ease the reality for us that Mother's earthly life was over.

One afternoon a few days before Mother died, when two nurses rolled her on her side she groaned, "Ouch." My mind went back to my early childhood, when we all spent summer nights on our sleeping porch hugged by lush lilac bushes. Now I felt that even in her coma, Mother was alive enough to sense her surroundings. Who's to say she couldn't smell the lilacs? I read her mail to her and would reread a few letters from earlier days just to reassure her (and myself) that she was not alone.

A good friend was hospitalized for five months and had to lie flat on her back and do nothing, so I regularly sent her a note on a colorful postcard. After she got out of the hospital, she thanked me—"You're the best pen pal I have"—and I realized that not sending a letter to someone because you know she can't answer is a sad loss. I've also written letters to people telling them the utter truth, and because it isn't what they asked for, I have never received replies. I'm still grateful I've tried to be honest.

A letter can be a most special gift if it is written for an unusual reason. My recently married friend, Eliza, told me she spent a lovely Sunday afternoon curled up in a comfortable chair facing a crackling fire, her feet tucked up under her, a hand-painted light-blue flowered basket brimming with a variety of stationery, stamps and pens at her side, writing thank-you notes for wedding presents. As she looked over her guest list, she realized she wanted to thank several friends for sharing in her celebration. Because she wanted them to know how much it meant to her that they were with her, she sent *them* thank-you notes. It gave her

immense pleasure to write those notes; now she makes this standard practice with her friends. It's fun to write and receive thanks simply for being a friend. There are no "how to" books on writing letters to friends because there are no "rights" and "wrongs" when you are caring and giving. After one of our family parties, my artist friend Nancy dropped off a thank-you letter written on notepaper bought at a museum, with a colorful Bonnard interior scene on the front. After saying how much she had enjoyed the evening, Nancy wrote about the incredible colors of the Bonnard painting and pointed out to me the introduction of a figure on the bottom right-hand side of the picture. Nancy, the artist, set out to thank us and ended up giving us an art lesson which was delightful and another way of saying "thank you." One friend wrote me after one of my letters to her: "You certainly were in a good mood when you wrote me last, Alexandra." (It is hard even to say "thank you" when you feel grumpy.)

Good manners, little kindnesses and thoughtfulness dictate that we write letters on special occasions—to congratulate, console and thank. I know a woman whose pushiness verges on bitchiness; she never writes thank-you letters: "They were lucky we *came* for dinner." But without letters that spring forth spontaneously without a formal reason or excuse, my daily life would lose its phosphorescence. And it is those very letters that are the most giving because they are the least expected and land like magic in your mailbox.

But remember, someone has to write first. Virginia Woolf wrote Vita the first letter breaking several months' silence at the beginning of their relationship.

Just the other day I received a picture of old friends taken during a house party weekend some twenty years ago. It was mailed to me by a friend (also in the photograph) with whom I have kept in touch. The fact that he was cleaning out a desk drawer on a rainy evening and stumbled upon the faded snapshot didn't lessen my excitement upon receiving it. He followed up his thought with action, which gave me a great deal of unexpected pleasure.

Why, my friend Sarah asked recently, is letter writing reserved for long-distance relationships? If you are seized with an incongruous or privately funny thought, send it on to someone who will appreciate it. A letter can be a spontaneous record of a sudden thought, an aesthetic memento, a photo or a good laugh. I have a part-time assistant who works for me on her breaks from Harvard. She always writes me little amusing notes and leaves them around my desk. I feel she's giggling to herself on paper and sharing her laugh with me. Another example is a mother of two grown sons who writes them serious letters about family matters so her thoughts will be clear and the letters can be saved. Jacques hand-delivers these letters to her sons who live nearby.

When my daughters were younger, they wrote me half-letters, half-drawings. I've saved every one. I'd find these treasures taped to their bedroom doors; that's where I always made a beeline upon coming home—day or night. I'm sure marriages could stay fresher, more exciting and loving if little *bons mots* and sentimental notes were passed back and forth and mailed more often.

When I worked at a large interior design firm before starting my own company, Peter always sent me little notes, clippings and love thoughts through the mail. The shipping clerk couldn't understand what was going on! After several months Tony took me aside, scratching his head, and inquired, "Don't you ever get to see Mr. Brown at home? The postmark on all his mail is stamped New York, so we know he wasn't away on a trip." When I explained that I looked forward to Mr. Brown's notes and clippings—they brightened my day—Tony smiled and said, "Whatever makes you happy, Sandie."

For years I had difficulty adjusting to returning to New York and our apartment after being away on a vacation. When I travel for business, I always keep in close touch with my office and home. But when I'm on holiday, I absolutely hate hearing from my office. It breaks the spell. Even good news makes me nervous. I remember once upon my arrival in Antigua with Peter and the girls I received word from Texas that I had been selected to decorate a bank. At first I was ecstatic, but then I realized the information was interfering with my getting a complete rest with my family. I spent the next ten days anxiously dreaming of the bank and making drawings in the sand, despite the fact that there was nothing constructive I could do until I returned to my office. Inevitably I suffered from reentry blues every time I came back from a vacation, no matter how wonderful it had been.

Eventually it dawned on me that my unrest had nothing to do with not wanting to be home. On the contrary, one of the greatest aspects of travel is return-

ing home to our personally created comforts, where everything is the way we like it and we are surrounded by all the things we love. The problem was doubt and fear: once our plane would touch down and we'd get into a taxi for the dismal trip home from the airport, I'd open my mind to my business I had so gladly neglected while away.

Being head of a company, I know only too well how much can go wrong in a day or a week in any business. One of my assistants lives a block away from my home; before I returned from Paris last summer, Laura dropped off a darling welcome-home note informing me that everything was all right and that she couldn't wait to see me in the morning. From that point on, I moved around the apartment, singing and unpacking; all my fears and worries disappeared. Everything worked out. I needed a personal note saying that business was okay.

Now we've made it a regular ritual. Someone always leaves me a welcome-home letter after a vacation. My reentry problems have vanished. No news is not good news once I'm back from a trip.

Writing Letters
Anywhere and Everywhere

Back on vacation at the beach, I sit gazing at the incredible beauty of the sky and water, listening to the pattern of the waves pounding to shore and then receding. I think of the pattern of my life, of particular

loving friends, of people who have touched me in special ways. I correspond with many of these people, telling them they are in my thoughts. To some I say "I love you" on paper. This is a refreshing and enriching experience for me, because while I might not at that moment want an array of friends sitting next to me on a beach chair, I can actually be with them in spirit by putting my thoughts on paper. I would not be inclined to tell someone in a bathing suit sipping a Diet Coke "I love you" if I were at a beach with that person next to me. It would seem glib somehow, almost like an advance, and awkwardly inappropriate. My solitude at a beach helps me open up my internal life and appreciate my blessings from a larger perspective.

When I fly I tuck a folder of stationery into my tote

bag. I spend my flight time daydreaming, writing in my journal. Invariably, I write several letters to friends. Apparently all of my letters to an English artist friend have been written on planes: Once she painted a picture of me racing for a flight, stationery in hand! The pure luxury of thinking of someone and having the time to write a long letter spontaneously is a real high for me; so much of my time is scheduled.

I always carry a few postcards and note cards in my Filofax notebook, and stamps too, so that when a thought strikes me I can quickly jot off a note to a friend. You can even prestamp the postcards, so that a few minutes is all it takes. Once I was in a traffic jam on Fifth Avenue and dashed off four postcards and two notes while the taxi driver was going nuts. I was as cool as a cucumber because I felt I had used the time wisely. Waiting for someone who is late for an appointment used to be frustrating for me. Now I never feel I'm wasting my time because I've learned I can use those few minutes (or in some cases longer!) as opportunities to write thank-you or catch-up notes. Any time, any place, you can put your thoughts on paper to a friend—at a café while sipping your coffee; on a bench in the park; on a bus; at a museum; in a lobby; at an airport; at the dentist. Don't wait until later. Later might be too late.

Letters can provide comfort anywhere. *The Pillow Book of Sei Shonagon,* expressing the thoughts of a Japanese court lady born circa 965, said:

> . . . If letters did not exist, what dark depressions would come over one! When one has been worrying about

something and wants to tell a certain person about it, what a relief it is to put it all down in a letter! Still greater is one's joy when a reply arrives. At that moment a letter really seems like an elixir of life.

A writer for *The New Yorker,* A. J. Liebling, remembered his student days at the Sorbonne in Paris in 1926–27. "I was often alone but never lonely." I think earnest letter writers, while often alone, are never lonely.

Many people who love to correspond use typewriters—they can't think when their fingers aren't dancing on the keyboard. Some claim they think too fast to write in longhand and they can type, on an average, thirty percent faster than they can write. My friend Jean says her handwriting is completely illegible. I take her at her word—the only example I've ever seen is an artistic signature that is more design than communication. Jean told me that years ago when she was in love with a starving artist she sent him a typewritten love letter he claimed he never received. Months later the mystery was revealed: He thought it was a bill, so he stuffed it in his desk drawer unopened!

My British corresponding artist friend has handwriting so cryptic that Peter has to decipher it; even after valiant attempts to decode her words, we sometimes end up losing about one in four. I feel dumb. In Anne's case we are all delighted when she types her letters, leaving no room for confusion and allowing me the pleasure of reading her thoughts without an interpreter. A journalist in Texas loves to type long, chatty letters to friends between the pressures of her

deadlines. When she's "stuck" she thinks of her friends!

A harried housewife in New Jersey chases after three small boys all day. The only time they don't disturb her is when she sits down at her desk in the bedroom, squarely behind her old Underwood and taps away— "Don't bother me now, Tommy. Mommy's busy working." Her letters (her work) are her salvation. They are so full of Little League, jokes, peanut butter, Band-Aids, Jell-O, marshmallows, car pools and sandbox expressions—they couldn't be written from an executive's swivel chair in a fancy high-rise office building. Jane's letters are hilarious, lively and refreshing; the typewriter helps her keep her sense of humor. Tommy, Jimmy and Billy think their mother is doing something very serious when she bangs away. In fact, they're right: She's keeping her sanity. The typewriter does have its place in personal correspondence.

Stanley Marsh, of Cadillac Ranch fame in Texas, has an oversized typewriter with a huge keyboard; he uses gigantic paper (14 \times 18 inches) and signs his signature with a rainbow of felt-tipped pens. Now, that's fun!

Years ago I wrote a letter to the great American interior designer Billy Baldwin, who was retired and living on Nantucket. After writing one draft I had my secretary type the letter. I looked at this formal document I was sending to someone I greatly admired, and it didn't feel right. It seemed cold. Why was I hiding behind the impersonal typewriter like a big shot with a secretary when I was writing a letter of praise from the heart? I sat down and rewrote the letter in long-

hand and mailed it, only to receive a long, handwritten letter on Billy B's famous Nile blue paper by return mail. That initial letter of mine started a correspondence and a wonderful friendship.

Upon my arrival home recently from a lecture I had given in Richmond, Virginia, I plucked out the handwritten letters from that day's mail. Among them I saw a hand-addressed envelope from my brother. As I drew a bubble bath, I put my glasses and several of the day's letters on the counter next to the tub so I could savor them while luxuriating in my bath. I saved Powell's letter for last, and when I finally opened it I discovered it was a dictated, typed business letter about a family matter. My instinct was to chuck it in the wastebasket and skim a book of poetry until my body felt rejuvenated. Business letters belong in offices, not bathtubs. I was fooled by the handwritten envelope. Vita, on the other hand, was fooled by the typewritten envelope Virginia sent her from Potsdam, but the letter was in longhand: "My spirits rose."

The English always hand-write the greeting and closing of every typed letter, which I find charming. Often I receive a typed note from a very busy person who then adds in pen some warm, personal greeting obviously not dictated to the secretary. Whether a person types or writes a letter is really a question of style, convenience and habit. So I won't quibble about this point—words you choose to convey what you think and feel will come alive no matter what form you select. Whatever is sincere and natural is always best. For example, a well-known friend corresponds with both Peter and me. Peter sends and receives typed

letters. He dictates everything he writes. I send and receive handwritten letters. I write out everything. Different strokes for different folks.

A Letter Is a Chapter in a Relationship

As an adult in a committed marriage, I realize I will never be able to explore fully all the relationships in my brief life. I've discovered, however, that it is always a joyful, wondrous and mysterious delight to receive a letter from one for whom you genuinely care who lets you know they care, too. Plato was right: two people of the opposite sex can love each other without physical involvement just as two people can deeply care for each other who are of the same sex. Letters satisfy my yearning to connect with others of all ages and both sexes. It would be impossible for me to be able to call someone a friend if that person were not someone I'd want to keep in touch with by letter.

After the initial publication of *The Road Less Traveled*, Dr. M. Scott Peck received many letters from readers. "They have been extraordinary letters," he told a friend of mine. "Intelligent and articulate without exception, they have also been extremely loving. As well as expressing appreciation, most of them have contained additional gifts: appropriate poetry, useful quotes from other authors, nuggets of wisdom and tales of personal experience. These letters have enriched my life."

The gift of a letter is powerful indeed. Each person involved is sharing a part of himself. There is that risk. There is that vulnerability. What if the words are misinterpreted? What if they were read by someone who, at that moment, didn't understand the nature of the interchange or the love?

Personal letters are first and final drafts of your feelings—100 percent pure, composed without an editor perched on your shoulder. Vita wrote Virginia from Teheran in the winter of 1927:

> . . . I wish I knew what life was all about and what place literature really held in it, to a God's-eye view. I wish at least I could be content to accept things because they *are*, instead of trying to poke back to their origins and discover *why* they are, and what they are made of.

Letters allow for unanswered questions and mistakes.

Privacy

The subjective experience of writing letters that are more than just thank-you notes may be prompted by manners or politeness but it becomes much more: It enters into our stream of intuitive feelings. Obviously, the writer wants to share his emotions and connect with the person to whom he is writing. Letters sent and received should have the same sense of confidentiality as one-on-one conversations. Just as diaries are private, a letter sent to a friend by someone who has

talked very personally on paper should also be considered private property. Although I tend to show Peter almost everything that comes through the mail, I reserve the right to have secrets and show him only what I want him to read. Occasionally it is necessary to have some correspondence that is between two people only. For example, Peter's law practice requires him to keep client matters confidential. And over the years, I've corresponded with a writer who has requested that the letters be read by me and me alone.

Usually I leave this matter of confidentiality up to the discretion of the person receiving my letters. Who should or should not read a letter depends on the circumstances. Jealousy could misconstrue the purest intentions. If I feel I don't want one of my letters to be read casually by others, I write "private" on the envelope. Winston Churchill, a great and courteous letter writer, often did that. I receive letters that say "personal" or "confidential." In the wrong hands, I'm certain this could stir up an intense curiosity. If I keep a letter casually lying around on my desk that is labeled "private" and someone reads it, I feel the way I would if someone violated the privacy of my diary by peeking inside. Peeping Toms deserve what they learn and accordingly have to live with the revelations. Incidentally, I've inadvertently opened envelopes addressed to my daughter who shares my name. I've even overlooked her middle name or initial on several occasions and have been rightly reminded that it is a most serious offense.

Since it is a federal crime to open someone else's first-class mail (a year in jail), I think even the most

conscientious secretary would not open an envelope for her boss if "private" were written on it. If you write a personal letter to the boss and he is away on a trip and requests that his secretary read the letter over the telephone, that is different because the decision was made by someone else. Often when I write someone a "private" letter, I receive a note from the secretary saying the person is away and the letter will be awaiting his return. There is always a risk in sending letters in these days when people donate their correspondence to libraries. Dozens of people might someday read the "private" letters we send. The person to whom we write might turn the "private" correspondence into a book. Personal letters or copies of private correspondence should not be passed on to others without the writer's permission. But these are risks I find I must take.

Giving

> *Love is not primarily a relationship to a specific person; it is an attitude, an ordination of character which determines the relatedness of the person to the world as a whole, not towards one object of love. If a person loves only one other man, his love is not love but a symbiotic attachment, or an enlarged egotism.*

> **—ERICH FROMM**

In order to make the necessary effort to pick up a pen, fill it with ink, find paper, an envelope and stamp, and sit still long enough to take time to inscribe a

message, I've concluded that you either have to truly admire or hate the other person. This attitude of passion stirs the blood and inspires action.

A letter never written or mailed has deeper significance than our merely being too busy. No one is too busy to tip a hat to someone he admires. We have to ask: "Busy doing what?" Whether it be a note to a friend whose son has been hospitalized, a woman who has just lost her husband, an eighth-grade English teacher who helped you improve your writing, a friend of your daughter's who is homesick on her exchange program from college—pick up your pen out of caring, appreciation and love. It is never a burden to lift someone else's spirits. People who feel they must write mean-spirited, bitter letters deserve the life they are entrapped in. They could be giving, when all they

do is take away. Consequently, there is no place in this book or in my life for hate mail.

Writing and mailing a generous letter is so life-enhancing, so rewarding to the writer and the person receiving it. Is it better to give than to receive? I like both. I want it all. I've discovered it is more difficult to receive something you haven't first given. Receiving is a reflection on the person giving. But a modest effort at little material expense can bring great enjoyment and rewards. Popping a letter into the post fills us with that glorious hope that we will lift someone's spirits and in return receive an answer that will likewise lift ours. Hope springs eternal. We can't lose anything because we've expanded our horizons as well as our vision by reaching out. If we do receive an answer, we have focused, made written eye contact and, who knows, possibly sparked a friendship. All this for the cost of a stamp!

Last year I met and became friends with an American antiques dealer—Robert O. Stuart from Limington, Maine, who is also chaplain at Bates College. We were at an antiques show in Houston, where I was lecturing and setting up an exhibit. Two days after we met, I invited him to have dinner with me and he accepted. "May we go to an Italian restaurant? Living in Maine makes me crave good Italian food," he asked, and he made reservations for four at a new restaurant. We were joined by his cousin Charles and his assistant, Alexandra. We sat down to dinner at 11 P.M., exhausted after a twelve-hour day on our feet. We were feeling somewhat punchy, and the evening was a serendipitous pleasure for each of us—we ended up

telling our first childhood memories, opening up to our own personal nostalgia and tears of laughter. Rob told me freely, without embarrassment, that he loved dropping his students quick, encouraging notes. Immediately I smiled in appreciation that my instinct was right. He was a giver—shown by his supportive handwritten notes.

By their very nature, giving people need others and tend to reach out to communicate. So we give out of a personal need. I am thankful that I need nurturing and love; I thrive when I feel really connected with others. Rob left the next morning at 5 A.M. Charles and Alexandra gave Rob a send-off breakfast. He left for Maine and he was then going on to a peace mission to Nicaragua.

Peter came down to Houston the next day and gave a wonderful introduction to my lecture, tracing the history of interior design in America since Edith Wharton's book *The Decoration of Houses.* I told Peter all about Rob and introduced him to Charles and Alexandra, who had stayed behind to mind the antiques booth.

Like ships passing in the night, Peter and Rob did not meet in Houston. But now they have met. I wrote Rob inviting him to meet us when he came to New York a few months later for a major Americana furniture auction at Sotheby's. We had dinner together along with Charles, and Rob has asked Peter to come to Bates College to give a lecture to the law students on the American law profession. Letters make special connections.

Edith Wharton began her autobiography *A Backward*

Glance with "A First Word." She said, "Years ago I said to myself: 'There's no such thing as old age; there is only sorrow.' I have learned with the passing of time that this, though true, is not the whole truth. The other producer of old age is habit: the deathly process of doing the same thing in the same way at the same hour day after day, first from carelessness, then from inclination, at last from cowardice or inertia. . . . Habit is necessary; it is the habit of having habits, of turning a trail into a rut, that must be incessantly fought against if one is to remain alive."

Letter writing is a habit that allows us to explore new trails all our lives. Each day is a fresh new adventure when we regularly send and receive letters.

The secret of life is communication. There is nothing nobler—except love. Dr. Aaron Stern, a psychiatrist, said that communicating is loving. Love requires action. Rilke wrote to a young student who was struggling to become a poet when Rilke was still a young man and had most of his greatest work before him. In his first letter he advised:

> You are looking outside, and that is what you should most avoid right now . . . go into yourself. Find out the reason that commands you to write; see whether it has spread its roots into the very depths of your heart; confess to yourself whether you would have to die if you were forbidden to write. This most of all: ask yourself in the most silent hour of our night: *must* I write? Dig into yourself for a deep answer. And if this answer rings out in assent, if you meet your life in accordance with this necessity; your whole life, even into its humblest and

most indifferent hour, must become a sign and witness to this impulse. Then come close to Nature. Then, as if no one had ever tried before, try to say what you see and feel and love and lose. Write about what your daily life offers you; describe your sorrows and desires, the thoughts that pass through your mind and your belief in some kind of beauty—describe all these with heartfelt, silent, humble sincerity and when you express yourself, use the things around you, the images from your dreams, and the objects that you remember. If your everyday life seems poor, don't blame *it;* blame yourself; admit to yourself that you are not enough of a poet to call forth its riches; *because for the creator there is no poverty and no poor indifferent place.*

Find a new beginning: Take up your pen. Scribble a note to a friend. Find more meaning in your life, more creative moments, more joy. Cicero reminded us that "all our deliberate acts aim at our happiness, and we are therefore always searching for the *beata vita* which is identified with the good."

The mail just arrived with three letters. I must close now so I can read my letters.

P.S. Write soon!

GRACE NOTES

- Read *Letters of E. B. White* and be enchanted.

- Honor National Handwriting Day by being conscious of your penmanship.

- The best way to improve your handwriting is to dot an "i" and cross a "t". Take time to enjoy the process.

- Change the color ink you use to add excitement for special occasions. If you always use red, use pink for Valentine's Day.

- Write a fan letter. You have nothing to lose and you'll probably get a response.

- If you receive an enchanting thank-you letter, write back; begin a correspondence.

- Store the letters you want to save in colorful boxes. Sit by a warm fire and read over old letters. Time changes everything and letters make memories lasting. When you read over a letter that no longer holds meaning for you, burn it. Save only the poignant ones.

- Go to the Kenneth W. Rendell Gallery, Inc. (Place Des Antiquaries, 125 East 57th Street, New York, NY) to see some great letters and autographs from history. Or write to Mr. Rendell for inquiries: 154 Wells Avenue, Newton, Massachusetts, 02159.

- Save all your good letters and the envelopes in flowered hat boxes. Opening the lid and browsing can bring you hours of joy and happy reflection.

- Put colorful ribbons around your most treasured letters. They hold mystical powers.

- Have a letter rack on your desk with an assortment of your different kinds of paper, note cards and postcards for inspiration to write a letter or a note.

- Illustrate a letter when you are in a creative, playful mood.

- When you find an envelope design and size you especially like, steam it open, use it as a pattern and make more envelopes like it. Create it in different colors and line it in glossy patterned wrapping paper or delicate pastel or printed tissue paper.

- Letters are intimate. Be intimate.

- When you write a letter and tell a story, you are multiplying the event and allowing it to live on.

- Take a travel portfolio of stationery with you whenever you travel.

- Never throw out a pretty box for stationery. After you've used up the paper you can restock the box with other paper that fits or use it to store letters you wish to save.

- G. Lalo Harmonie has attractive blue foldover notepaper with a double border of blue and white, 4¼ × 5¾ inches.

- When next in Paris, go to Cassegrain Graveur, 422 Rue St. Honoré, and stock up on a variety of stationery. They also carry G. Lalo *"la nouvelle lettre"* foldover envelope letters with hand-painted borders and perforated edges, a snappy version of the post office-issue air mail envelope letter. They come in pink and blue.

- After splurging on stationery you can do what Vita Sackville-West did and lock up your stationery as well as your private letters.

YOUR GRACE NOTES

YOUR GRACE NOTES

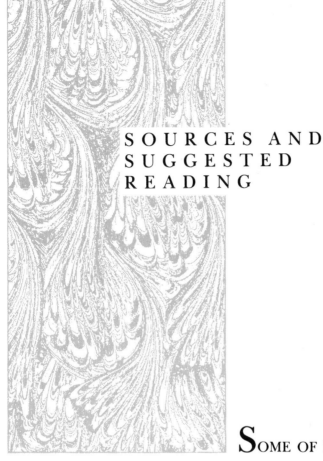

SOURCES AND SUGGESTED READING

SOME OF MY favorite sources for letterwriting accessories:

Vito Giallo Antiques
966 Madison Avenue
New York, New York 10022

Mediterranean Shop
876 Madison Avenue
New York, New York 10021

James II Galleries Ltd.
15 East 57th Street
New York, New York 10022

Il Papiro
1021 Lexington Avenue
New York, New York 10021;

250 Vesey Street
New York, New York 10281

Some of my favorite stationery and pen sources:

Tiffany & Co., Engravers of
 Social Stationery
57th Street and Fifth Avenue
New York, New York 10022

Crane & Co. Inc.
Check at your local statio-
nery store and fine depart-
ment stores.

Dempsey & Carroll,
 Engravers of Fine
 Stationery
110 East 57th Street
New York, New York 10022

Hallmark
Check your local telephone
listing.

Francis-Orr Stationers
320 North Camden Drive
Beverly Hills, California
90210

Smythson of Bond Street
54 New Bond Street
London, England

Cartier, Engravers of Social
 Stationery
725 Fifth Avenue
New York, New York 10022

John Ludlam Fine Stationer
1800 Post Oak Boulevard
Houston, Texas 77056

Agry
14 Rue Castiglione
Graveur Armoiries,
Chevalières, Paris, France

Benneton
Graveur Heraldiste
75, Boulevard Malesherbes
75008 Paris, France

Suggested Reading

Letters of Henry Miller and Wallace Fowlie, 1943–1972, by Henry Miller and Wallace Fowlie. New York: Grove Press, 1975.

Letters from Father: The Truman Family's Personal Correspondence, edited, annotated and with Introduction by Margaret Truman. New York: Arbor House, 1981.

Letters of C. S. Lewis, edited by W. H. Lewis. New York: Harcourt Brace Jovanovich, 1966.

The Letters of Vincent Van Gogh, edited by Mark Roskill. New York: Atheneum, 1984.

Letters to Alice on First Reading Jane Austen by Fay Weldon. New York: Taplinger, 1984.

The Letters of Lewis Carroll, 1837–1898, 2 vols., edited by Morton H. Cohen and Roger L. Green. New York: Oxford University Press, 1979.

The Collected Letters of D. H. Lawrence, 2 vols., edited by Harry T. Moore. New York: Viking, 1962.

The Letters of Robert Frost to Louis Untermeyer. New York: Holt, Rinehart & Winston, 1963.

The Letters of Henry Wadsworth Longfellow, vols. 1–2, 1814–1843, edited by Andrew R. Hilen. Cambridge: Belknap/Harvard University Press, 1967.

Letters to W. B. Yeats, vols. 1–2, edited by Richard J. Finneran, George Mills Harper and William M. Murphy. New York: Columbia University Press, 1977.

Letters of Archibald MacLeish, 1907 to 1982, edited by R. H. Winnick. Boston: Houghton Mifflin, 1983.

The Letters of Virginia Woolf, (Vol. 2: 1911–1922), edited by Nigel Nicolson and Joanne Trautman. New York: Harcourt Brace Jovanovich, 1976.

Dear Bess: The Letters from Harry to Bess Truman 1910–1959, edited by Robert H. Ferrell. New York: W. W. Norton, 1983.

Letters Home by Sylvia Plath, 1950–1963, selected and with commentary by Aurelia Schober Plath. New York: Harper & Row, 1975.

Lawrence Durrell & Henry Miller: A Private Correspondence. E. P. Dutton, 1963.

Letters of George Sand and Gustave Flaubert, translated by Stuart Sherman. Chicago: Academy Chicago, Ltd., 1929, reprinted 1979.

Letters of Anton Chekhov, edited by Avrahm Yarmolinsky. New York: Viking Press, 1973.

War Within and Without: Diaries and Letters, 1939 to 1944, by Anne Morrow Lindbergh. New York: Harcourt Brace, 1980.

Letter to the Alumni, by John Hersey. New York: Alfred A. Knopf, 1970.

To Marietta from Paris, 1945–1960, by Susan Mary Alsop. New York: Doubleday, 1975.

Letters to His Son Lucien by Camille Pissarro, Paul P. Appel. Originally published in 1944, revised and enlarged in 1972. Layton, Utah: Peregrine Smith, Inc.

Letters of Ranier Maria Rilke, 1892–1910, 1910–1926, tr. by Jane Bannard Green and M. D. Herter Norton. New York: W. W. Norton, 1945.

Jane Austen—Selected Letters, 1796–1817, edited by R. W. Chapman. Oxford: Oxford University Press, 1985.

The Book of Abigail and John, Selected Letters of the Adams Family, 1762– 1784, edited and with an introduction by L. H. Butterfield, Marc Friedlaender, and Mary-Jo Kline. Cambridge: Harvard University Press, 1975.

Letters from Collette, selected and translated by Robert Phelps. New York: Farrar, Straus & Giroux, 1980.

The Letters of Edith Wharton, edited by R.W.B. Lewis and Nancy Lewis. New York: Charles Scribner's Sons, 1988.

Letters of E. B. White, compiled by Dorothy Lobrano Guth. New York: Harper & Row, 1976.

C. G. Jung Letters, selected and edited by Gerhard Adler and Aniela Jaffe. Princeton: Princeton University Press, 1973.

Selected Letters of E. M. Forster, 1879–1920, edited by Mary Lago and P. N. Furbank. Cambridge: Belknap/Harvard University Press, 1983.

Hour of Gold, Hour of Lead: Diaries and Letters, 1929–1932, Anne Morrow Lindbergh. New York: Harcourt Brace Jovanovich, 1973.

Bring Me a Unicorn: Diaries and Letters of Anne Morrow Lindbergh, 1922–1928. New York: Harcourt Brace Jovanovich, 1971.

Rilke and Benvenuta: An Intimate Correspondence, edited by Magda von Hattingberg, translated by Joel Agee. New York: Fromm International Publishing, 1987.

The Prettiest Love Letters in the World: The Letters Between Lucrezia Borgia and Pietro Bembo 1503 to 1519, translated by Hugh Shankland. Boston: David R. Godine, Publisher, 1987.

Letters on Cézanne, Rainer Maria Rilke. New York: Fromm International Publishing, 1985.

Letters of Great Artists, Vols. I and II. New York: Random House, 1963.

The Treasury of the World's Great Letters: From Ancient Days to Our Own Time, edited by M. Lincoln Schuster. New York: Simon & Schuster, 1940.

A Letter of Consolation, by Henri J. M. Nouwen. New York: Harper & Row, 1982.

Letters to a Young Poet, by Rainer Maria Rilke, translated by Stephen Mitchell. New York: Random House, 1984.

The Letters of Vita Sackville-West to Virginia Woolf, edited by Louise DeSalvo and Mitchell A. Leaska. New York: William Morrow, 1985.

Crane's Blue Book of Stationery, edited by Steven L. Feinberg. New York: Doubleday, 1989.

MAKING CHOICES
71625-9/ $12.50 US/ $16.50 Can

GRACE NOTES
72197-X/ $9.00 US/ $13.00 Can

LIVING A BEAUTIFUL LIFE
70511-7/ $12.50 US/ $15.00 Can

LIVING BEAUTIFULLY TOGETHER
70908-2/ $14.00 US/ $19.00 Can

GIFT OF A LETTER
71464-7/ $10.00 US/ $13.00 Can

DARING TO BE YOURSELF
71578-3/ $14.00 US/ $19.00 Can

CREATING A BEAUTIFUL HOME
71624-0/ $14.00 US/ $19.00 Can

TEA CELEBRATIONS
72324-7/$9.00 US/ $12.00 Can

THE ART OF THE POSSIBLE
72618-1/$12.50 US/ $16.50 Can

MOTHERS: A CELEBRATION
72619-X/$12.00 US/ $16.00 Can